CW00683776

LOOK UP LONDON

LOOK UP LONDON

World class architectural heritage
that's hidden in plain sight

ADRIAN SEARLE
& DAVID BARBOUR

FREIGHT
BOOKS

First published 2014

Freight Books
49–53 Virginia Street
Glasgow, G1 1TS
www.freightbooks.co.uk

A CIP catalogue reference for this book is available from the British Library

ISBN 978-1-908754-72-1

Typeset by Freight in Adobe Caslon Pro and Tungsten
Printed and bound by PB Print UK in the Czech Republic

We publish with investment from
Creative Scotland toward the publication of this book

CONTENTS

FOREWORD

With a history dating back 2,000 years, and boasting some of the globe's most iconic buildings – from the Tower of London, Buckingham Palace and the Palace of Westminster to the Lloyds Building, the Gherkin and the Shard, to name very few – London is one of the world's greatest cities. It was the biggest city on the planet for nearly a century and its finance, fashion, advertising, art, theatre, music and literature, and countless other endeavours, are as influential as those of any other city worldwide.

In 2013 I published, together with photographer David Barbour, the book *Look Up Glasgow*, inspired by the outstanding, world-class architectural sculpture and decoration to be found 'hidden in plain sight', in ridiculously high concentrations, at the tops of buildings throughout the 'Second City of the Empire'. The book was a great success and, with a real passion for architectural heritage, we turned to the UK's capital city for further inspiration. David lived in London for nearly 20 years and together we explored, seeking out its very best examples of architectural sculpture and decoration.

Man has been making figurative sculpture for tens of thousands of years, ever since he learned to hold a stone axe. What it is that makes us want to capture and reimagine the world around us through art is something that has challenged art historians and philosophers for almost as long. But it's my strong belief that architectural decoration, whatever form it takes, is a vital part of our relationship with our environment.

Buildings are not just walls and a roof. Architecture is a conversation between a structure, its surroundings and the people who exist within it – as *Grand Designs'* Kevin McCloud loves to say. And to my mind, sculpture and decoration help extend that conversation. They help people understand what a building means, help them respond to it in their own unique and individual way. Most importantly, they help us form a relationship with our environment.

With architecture from a number of eras, and a vast range of styles, *Look Up London* is a visual feast, for Londoner and visitor alike. This book is very much a personal selection and it not intended to be exhaustive. I daresay we could have travelled further and included more had time allowed. If I have missed out a favourite piece of sculpture of yours, I humbly apologise.

My principal interest is in decoration on the sides of secular buildings. Generally I've tried to avoid ecclesiastical architecture and monuments as these are specialist subjects in their own right. However, it was impossible to exclude them completely. We've made some personal choices of iconic churches and plinths we particularly like although, for the vast majority of the book, we've focused on secular sculpture.

I make no apology for using the images here to inspire one of London's most exciting young poets. It's a pleasure and a privilege to have been able to commission Clare Pollard to write verse on the subject of London's wealth of architectural decoration. These poems provide moments of reflection on the artworks themselves while connecting the past to the present day.

I owe acknowledgement and appreciation to Philip Ward-Jackson, author of *Public Sculpture of the City of London* (Liverpool University Press, 2003) and *Public Sculpture of Historic Westminster* (Liverpool University Press, 2011), Terry Cavanagh, author of *Public Sculpture of South London* (Liverpool University Press, 2007) and Frank Lloyd, Helen Potkin and Davina Thackara, co-authors of *Public Sculpture of Outer South and West London* (Liverpool University Press, 2011). All these scholarly titles proved to be invaluable resources in the making of this book.

Confession time. I admit that I love brutalist modern architecture. As a passionate collector of Danish mid-century furniture, I draw huge pleasure from the purity of style championed in the 1960s and 70s. I don't agree with Prince Charles's assertion that most modern architecture is a "monstrous carbuncle". However, I also love the ebullience of older buildings that have the confidence to use sculpture, decoration and ornament to entertain and educate those of us passing by on a daily basis. That many of these fabulous works of art have become damaged or corroded by pollution amounts to cultural vandalism. It's also a real shame that contemporary architecture doesn't make use of sculpture and decoration more often.

But for me, the real tragedy is that so many of us have become immune to the delights around and above us. We're so focused on where we need to be next, or what we're about to buy, that we forget to stop, look up and enjoy the fabulous wealth of stunning architectural heritage that surrounds us.

So the next time you're in the centre of this great city, whether as inhabitant or visitor, remember the cry: Look Up, London!

— Adrian Searle

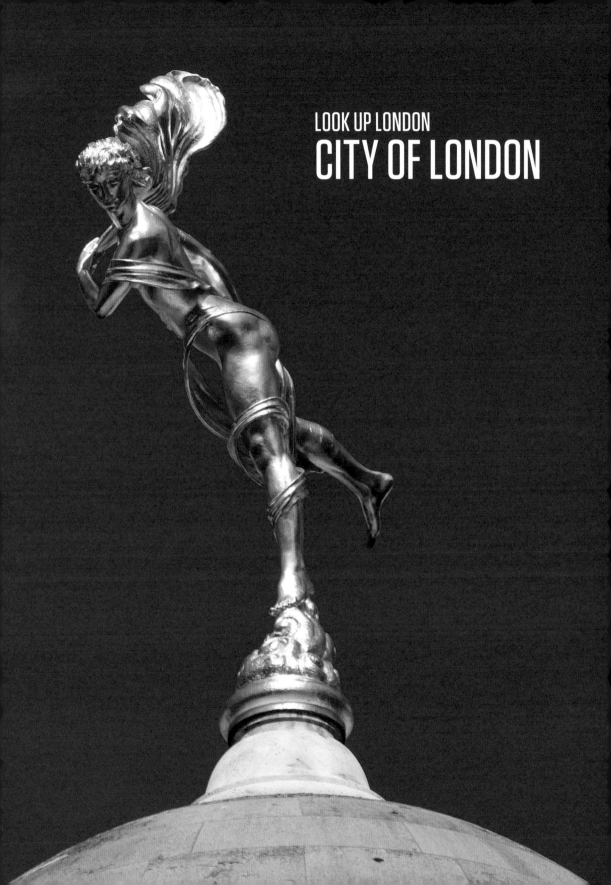

LOOK UP LONDON
CITY OF LONDON

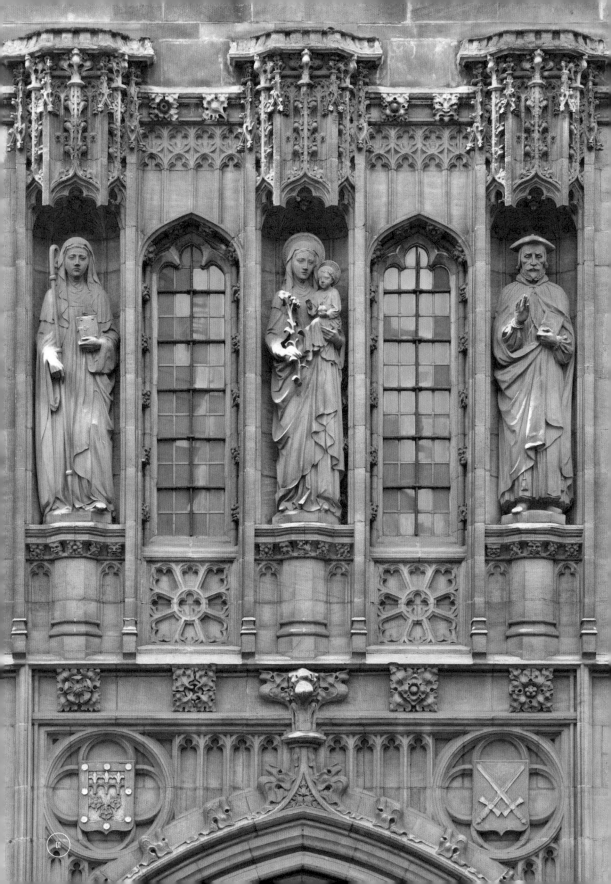

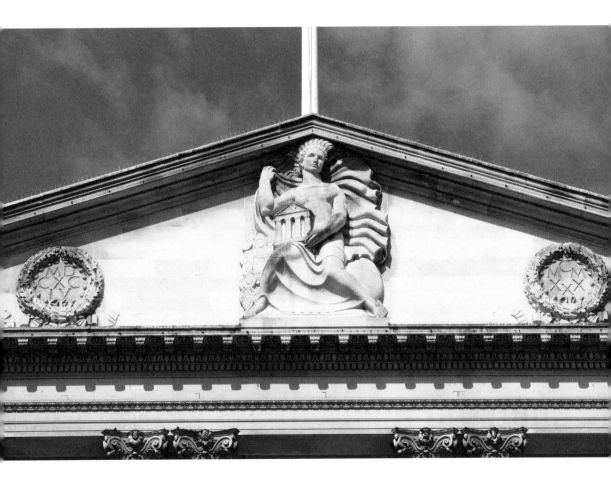

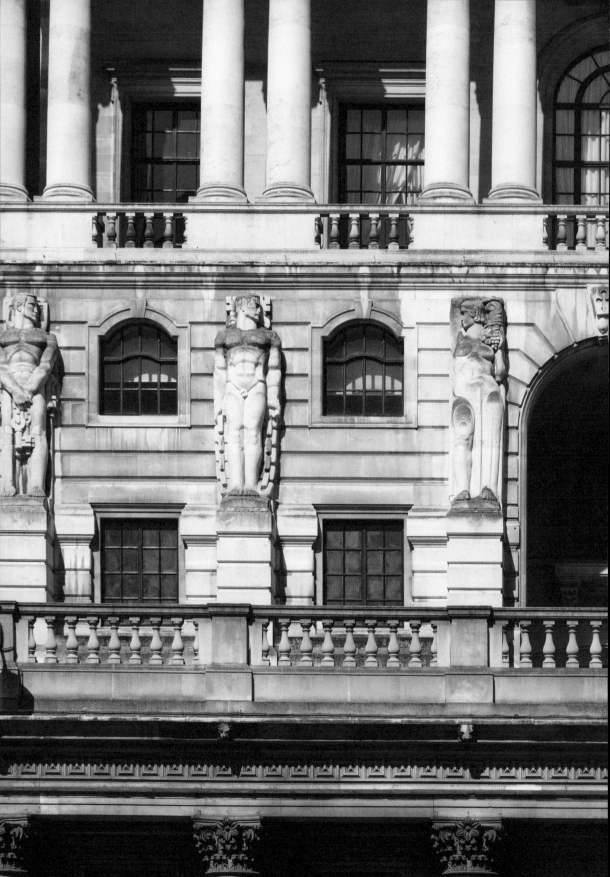

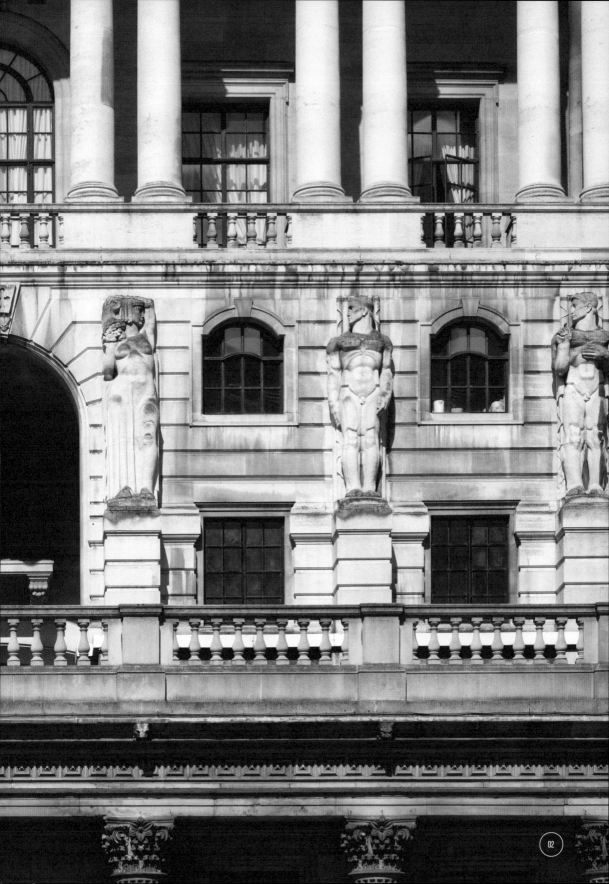

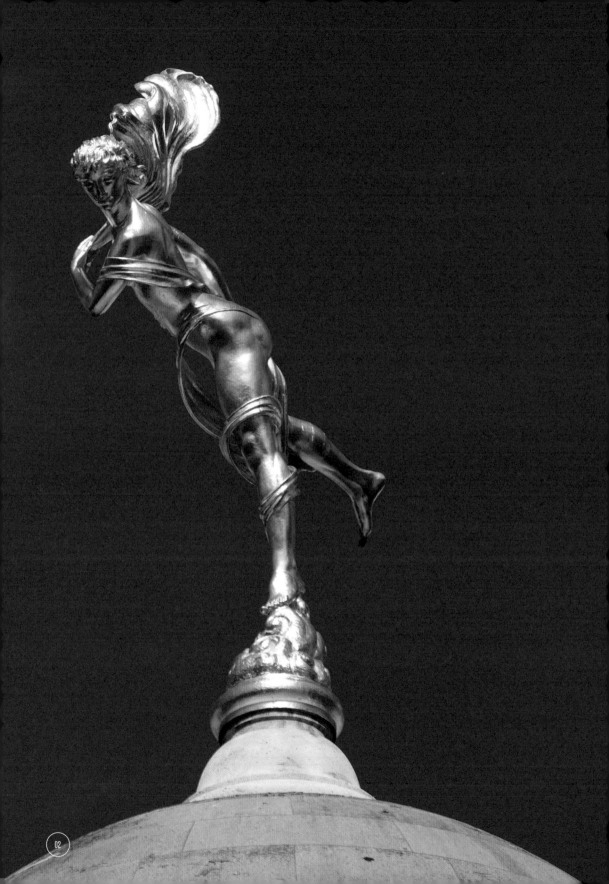

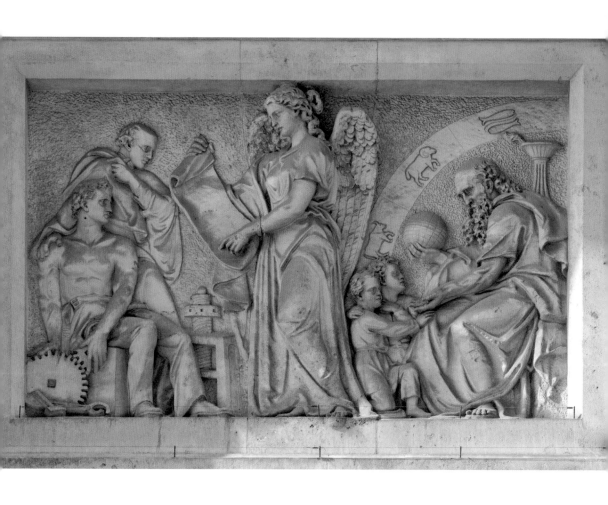

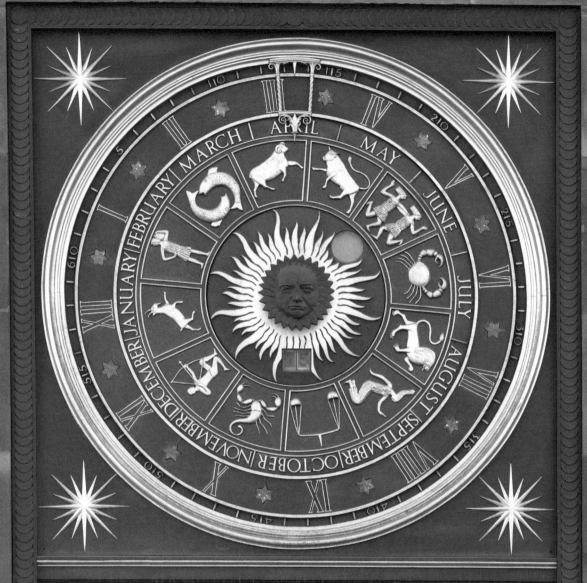

BRACKEN HOUSE

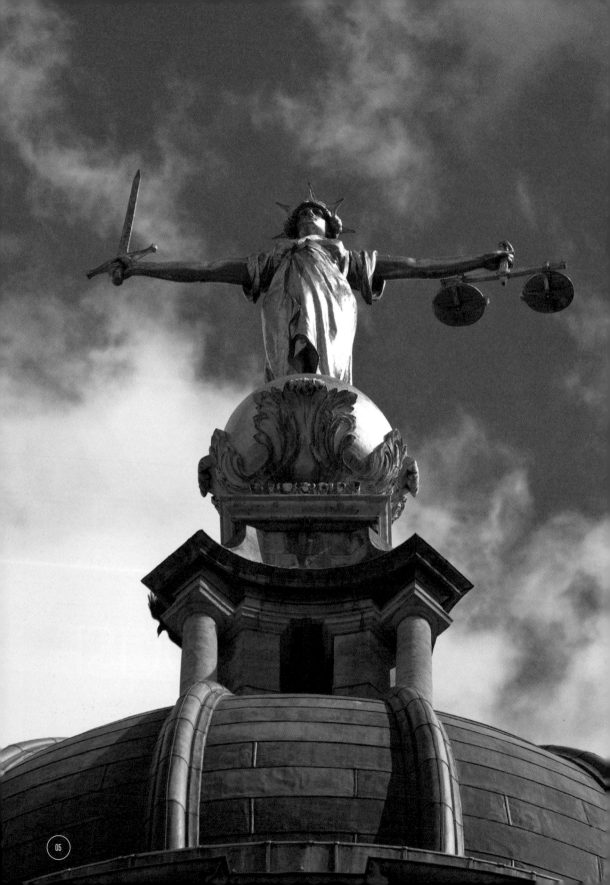

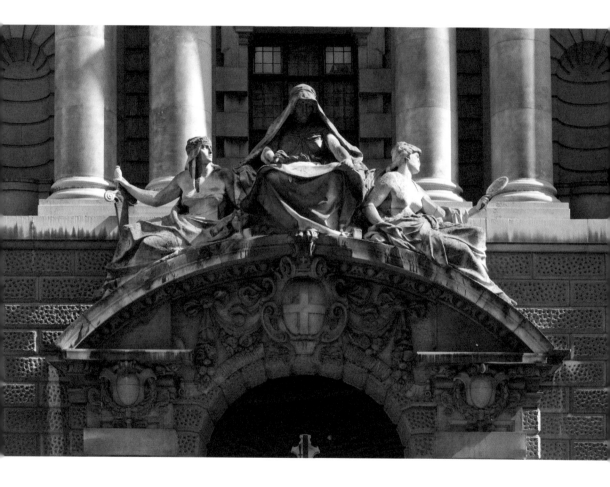

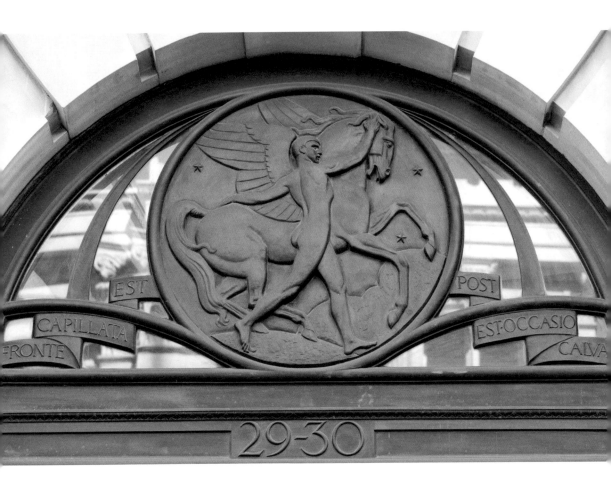

EST
CAPILLATA
FRONTE

POST
EST·OCCASIO
CALVA

29-30

06

06

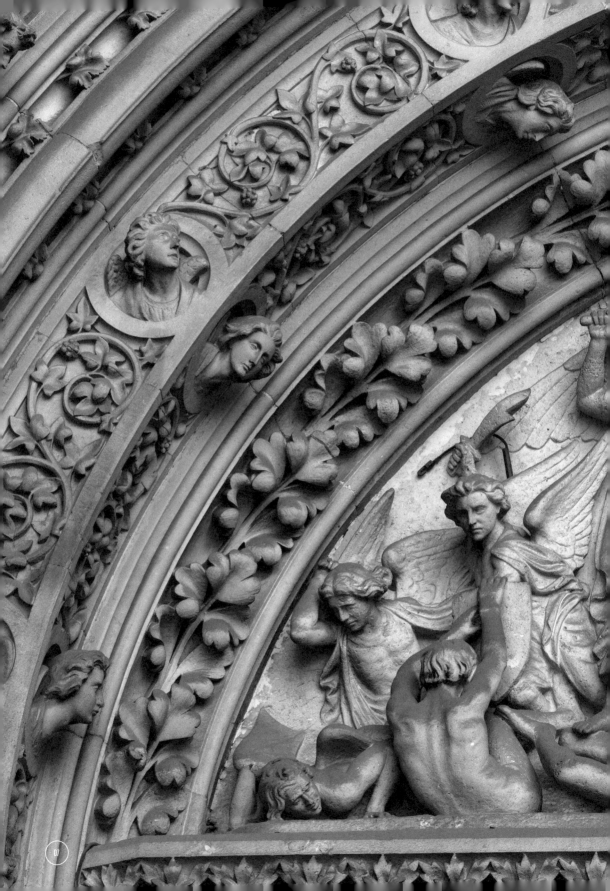

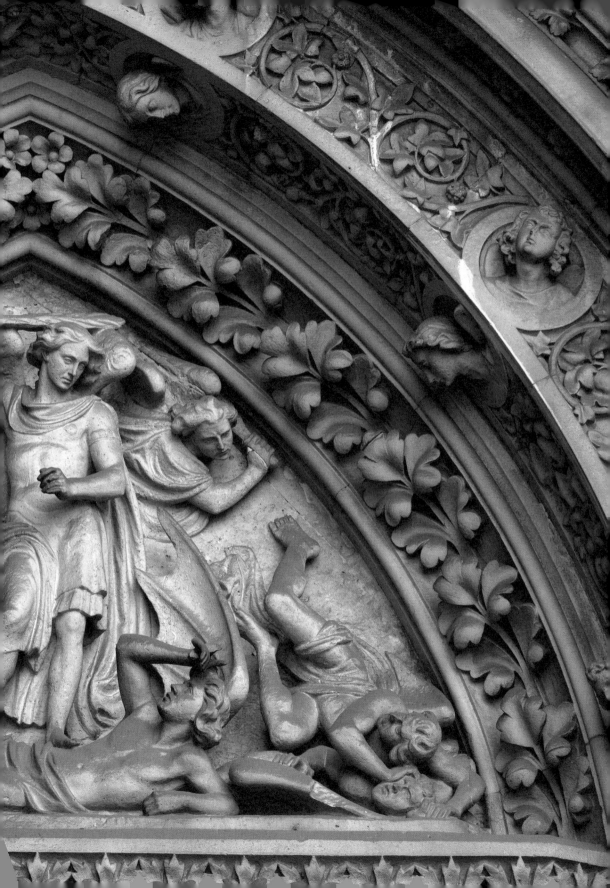

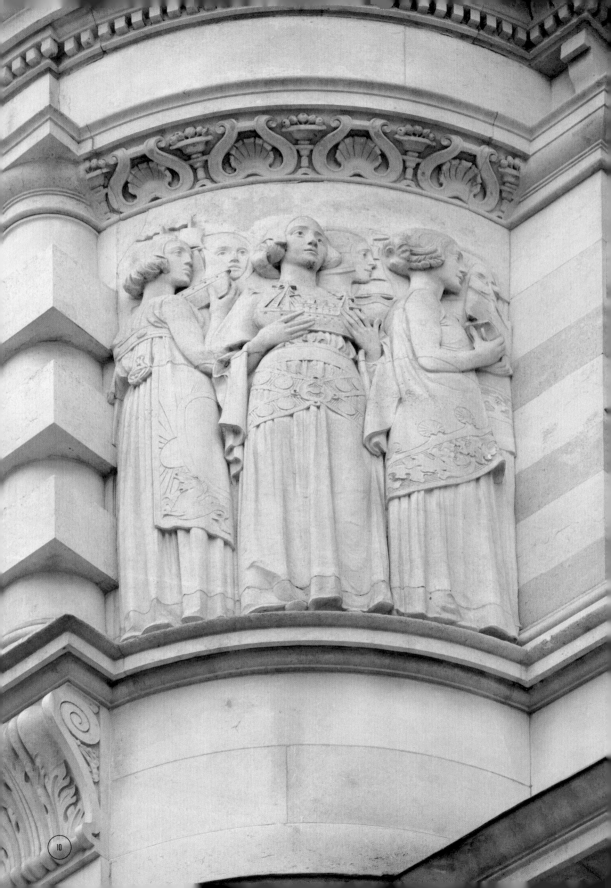

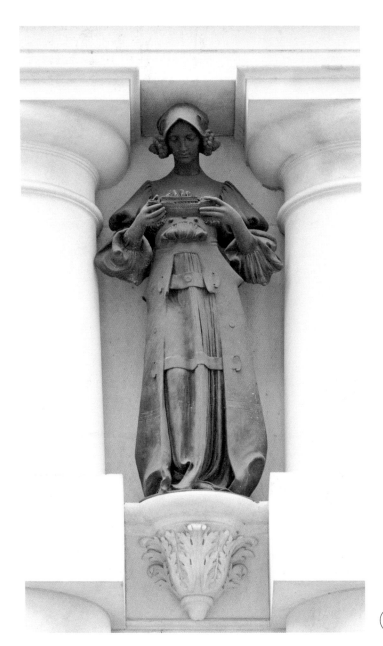

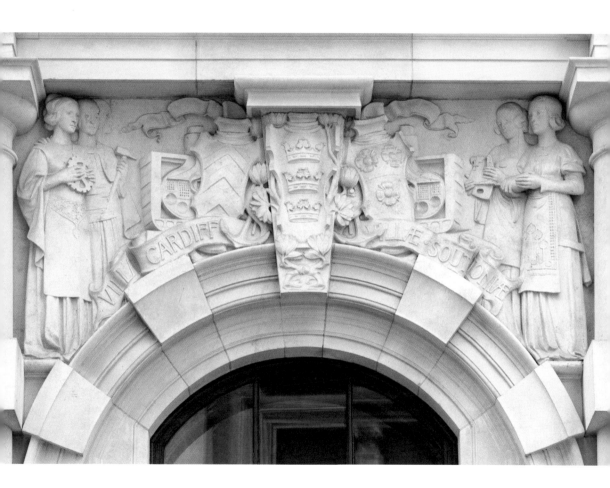

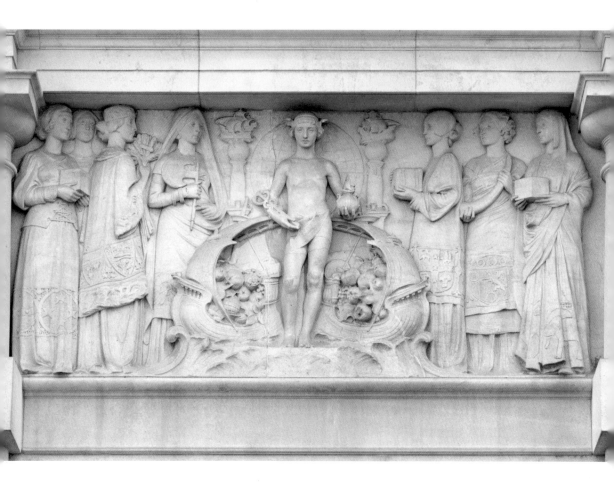

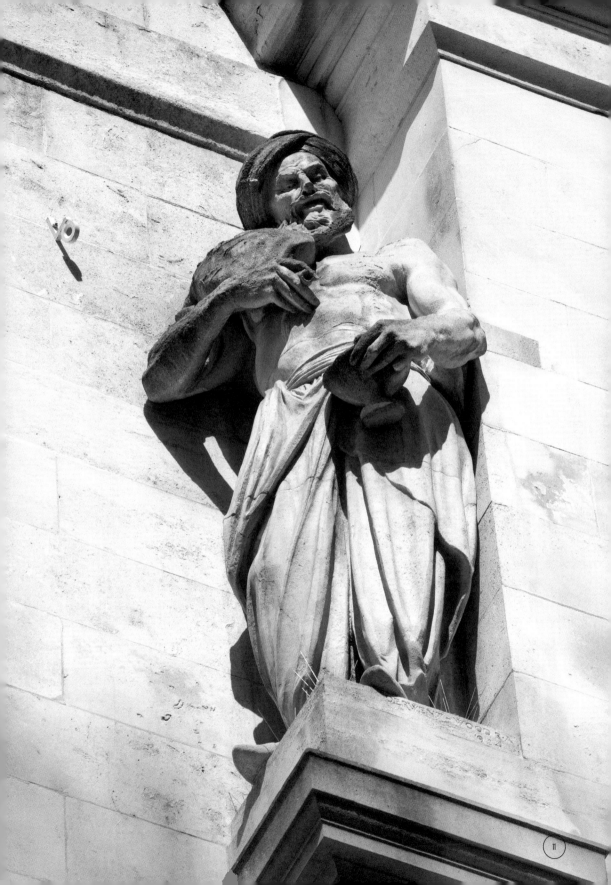

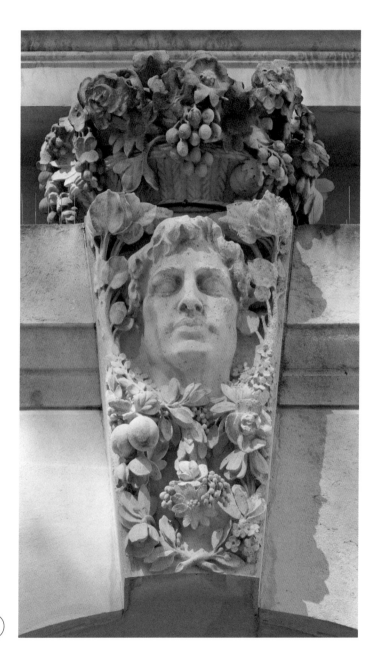

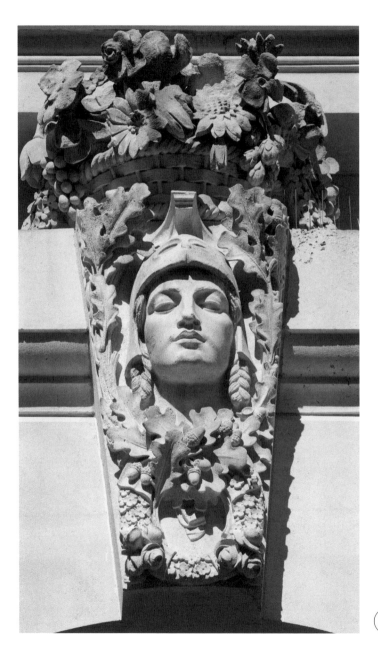

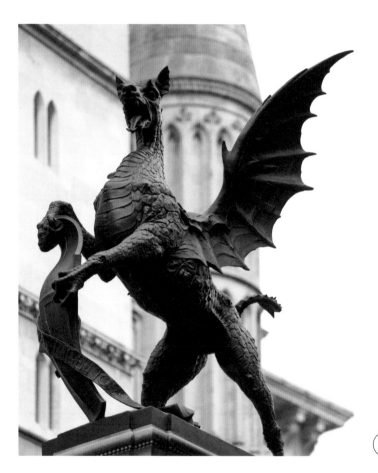

SCIENCE

ART

ΟΜΗΡΟΣ

13

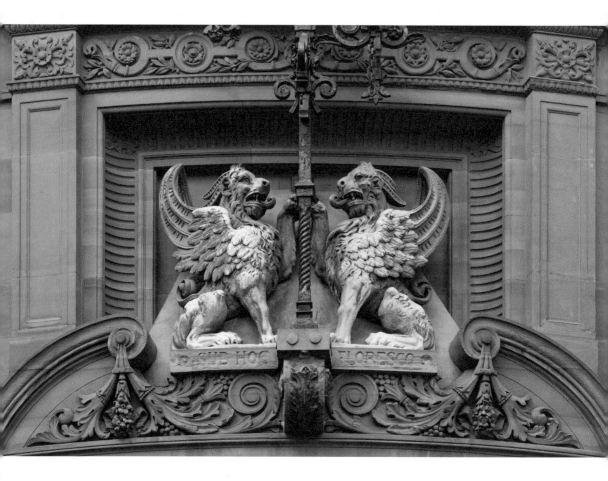

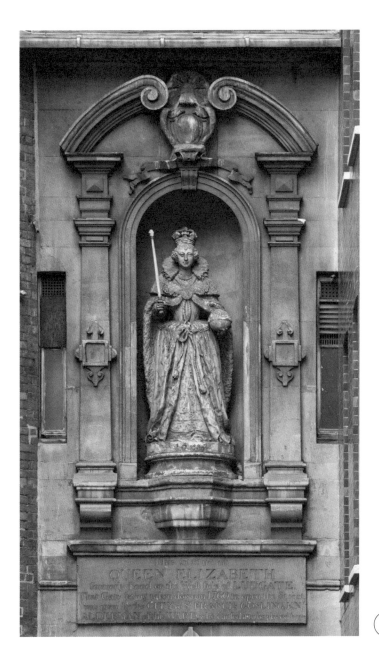

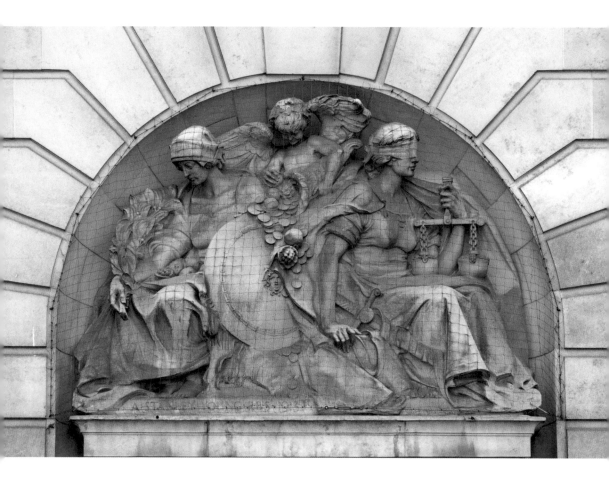

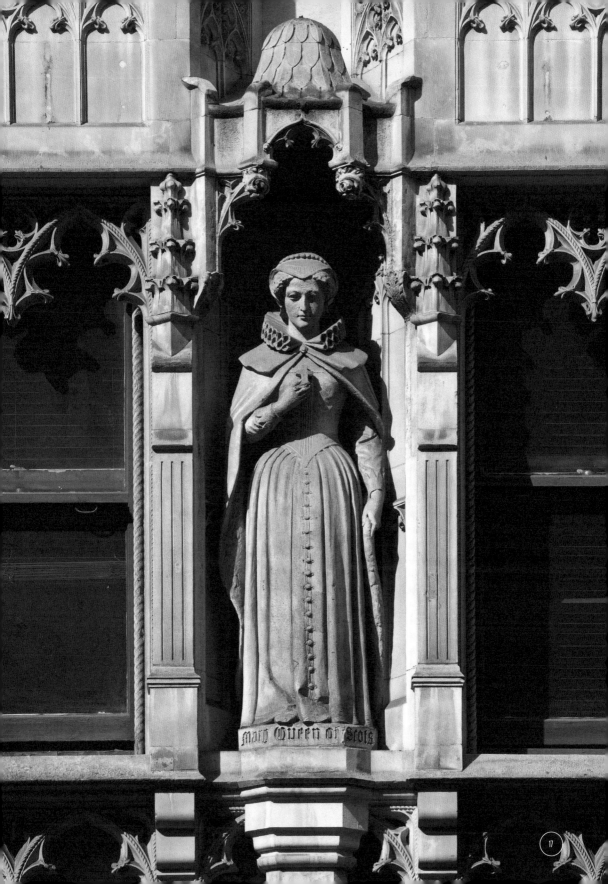

Mary Queen of Scots

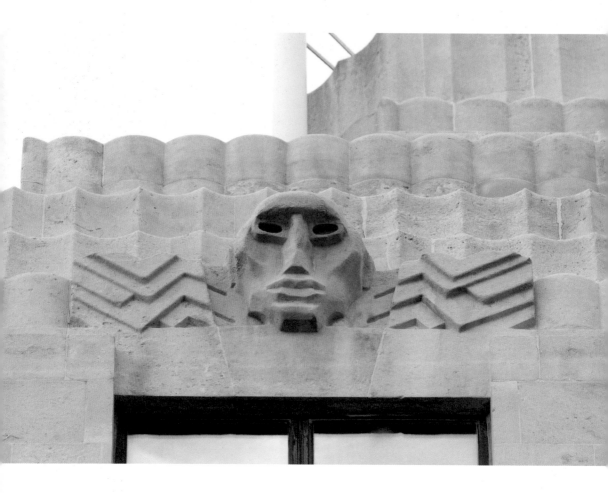

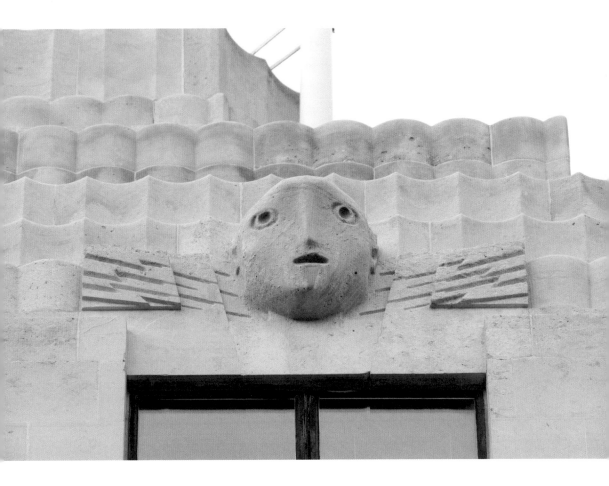

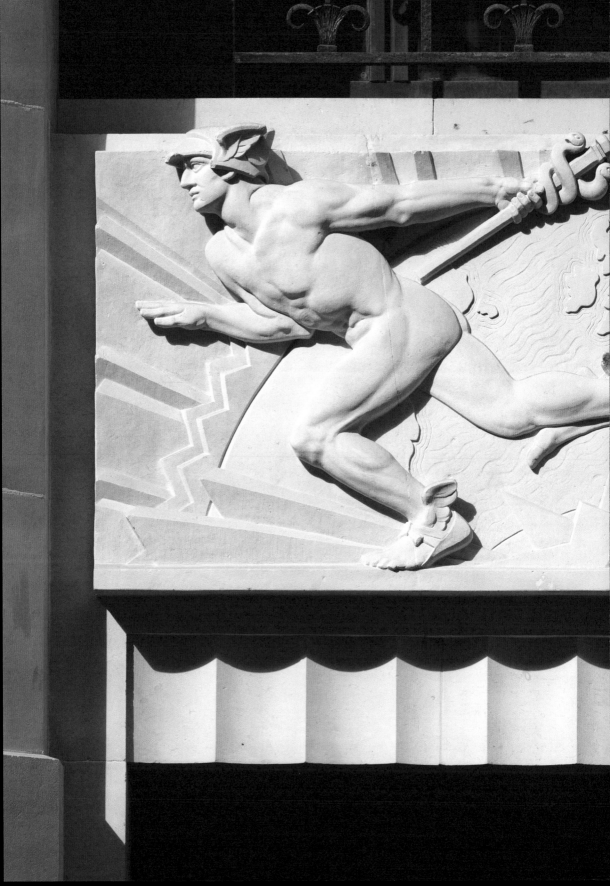

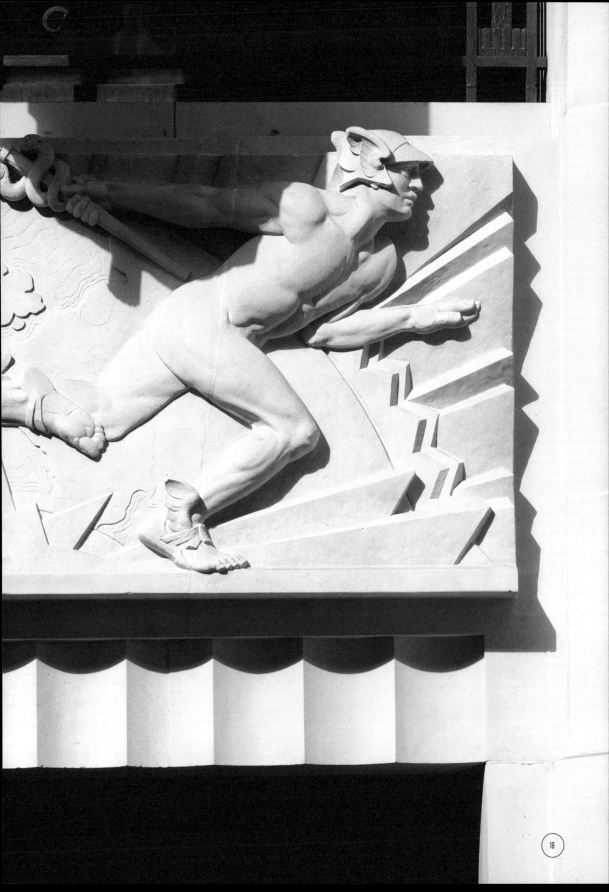

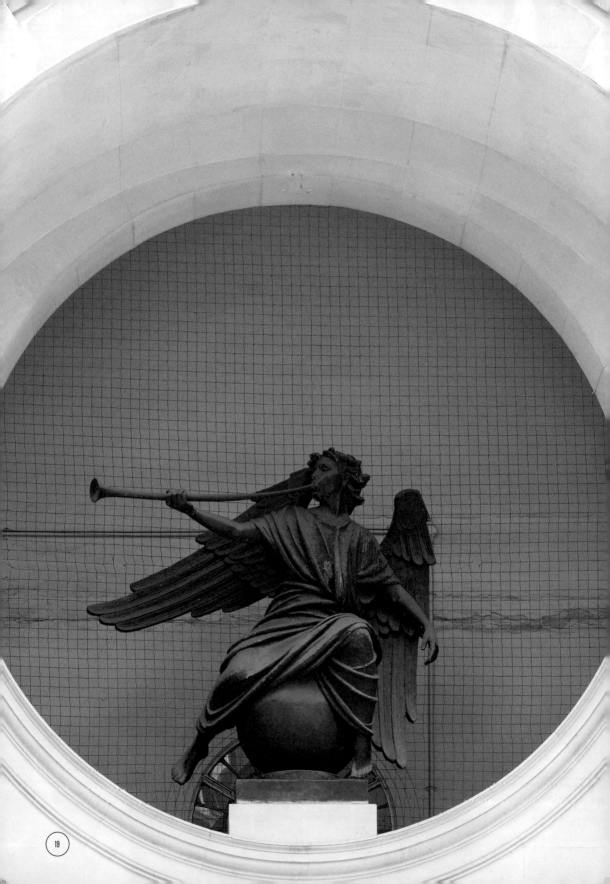

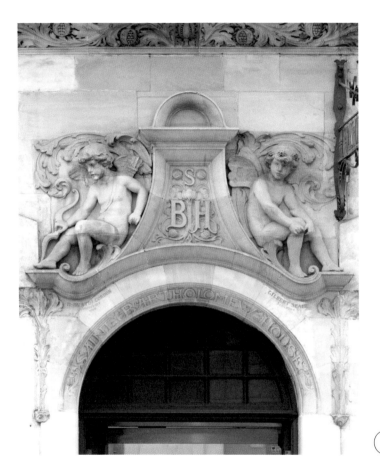

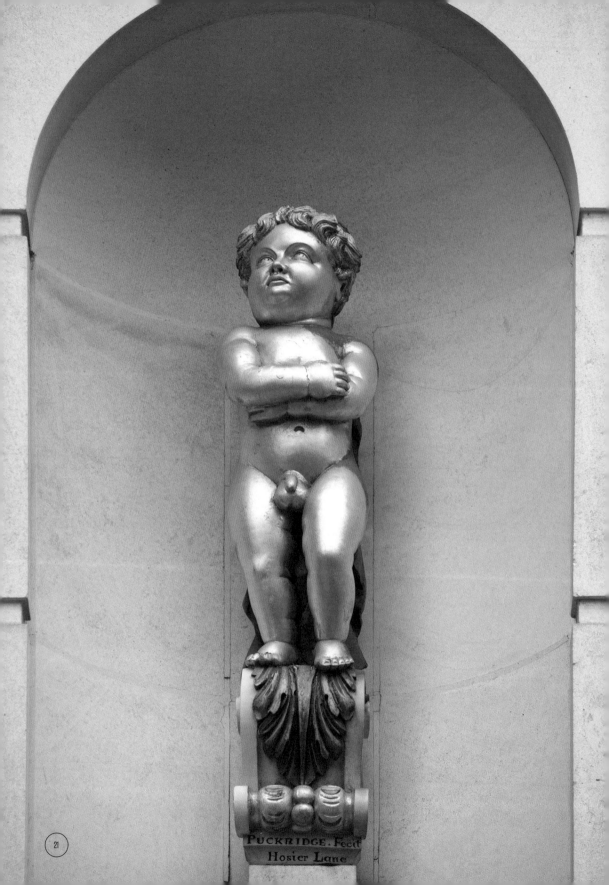

PUCKRIDGE. Fecit
Hosier Lane

On Pie Corner

Clare Pollard

'This Boy is in Memmory Put up for the late FIRE of LONDON
Occasion'd by the Sin of Gluttony 1666' *Inscription*

Between Giltspur and Snow Hill
they come looking for Cock Lane
for the stews and Scratching Fanny,

and they came to see flame take -
watch lives blistering and cracking,
how it ate from Pie to Pudding.

Between Giltspur and Snow Hill
is a street concerned with meat:
with the tupping and the dipping,

and the corpses sold for cutting,
and the mashing and the liquor
that a good pie needs for guzzling.

See that gilded boy? A glutton,
only four and pudgy mutton -
he deserved what he had coming.

If you eat cheap flesh and tricks,
if you're born that poor or fat,
you're a sinner from the cot.

And God or someone like him
will raze you; burn you down:
fire your babies into gold.

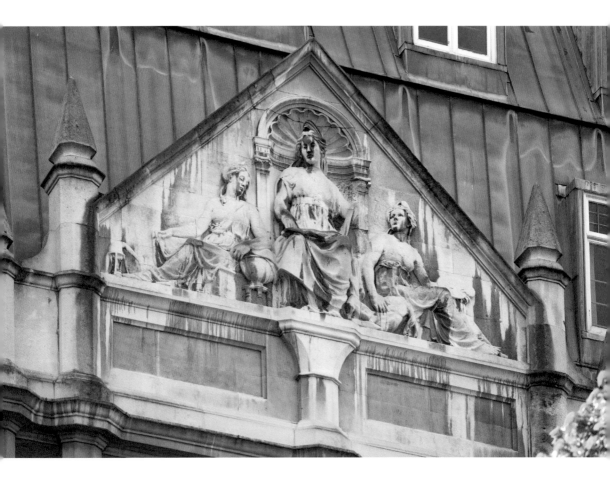

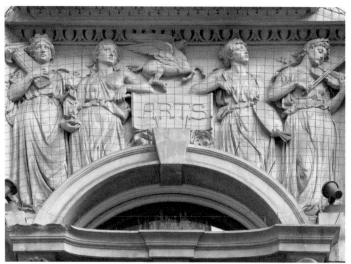
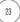

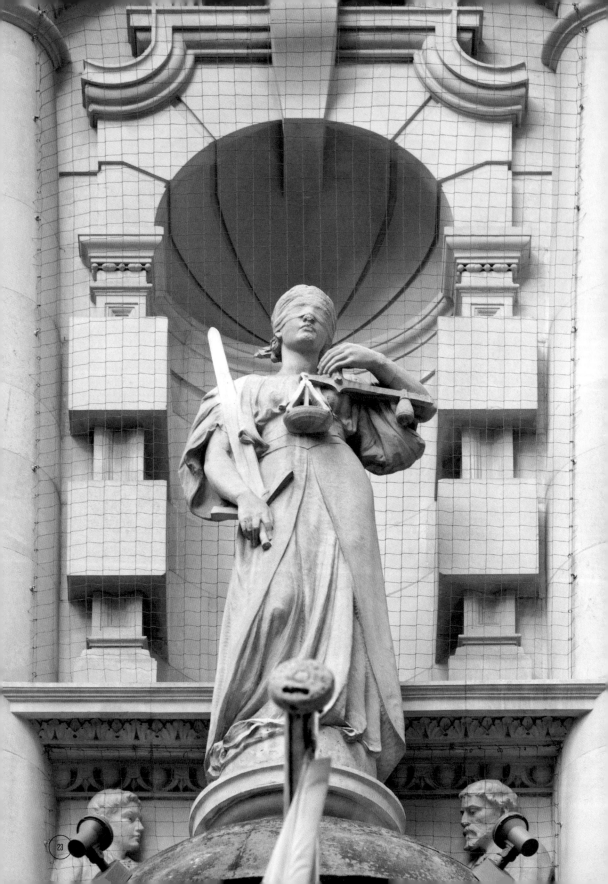

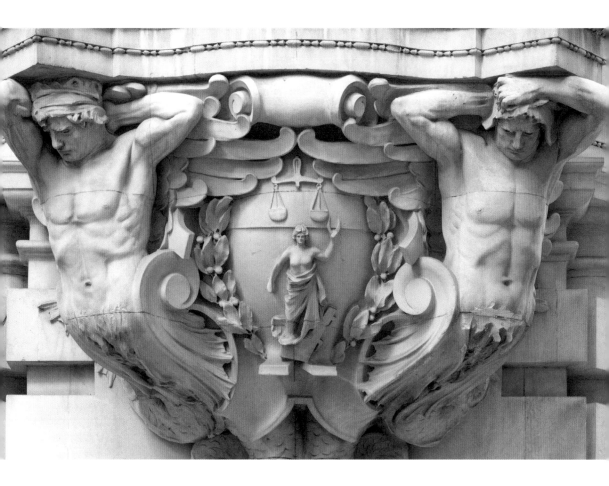

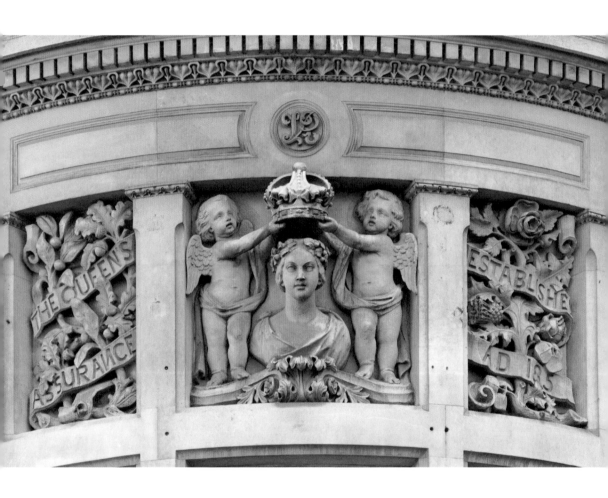

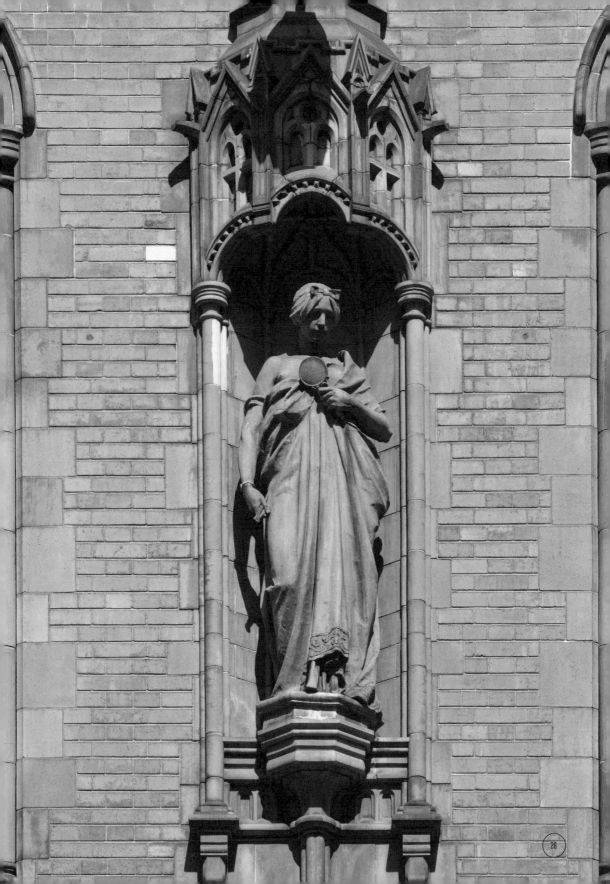

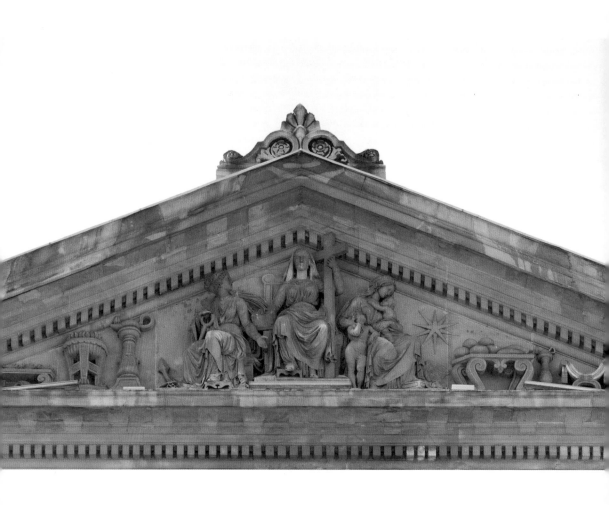

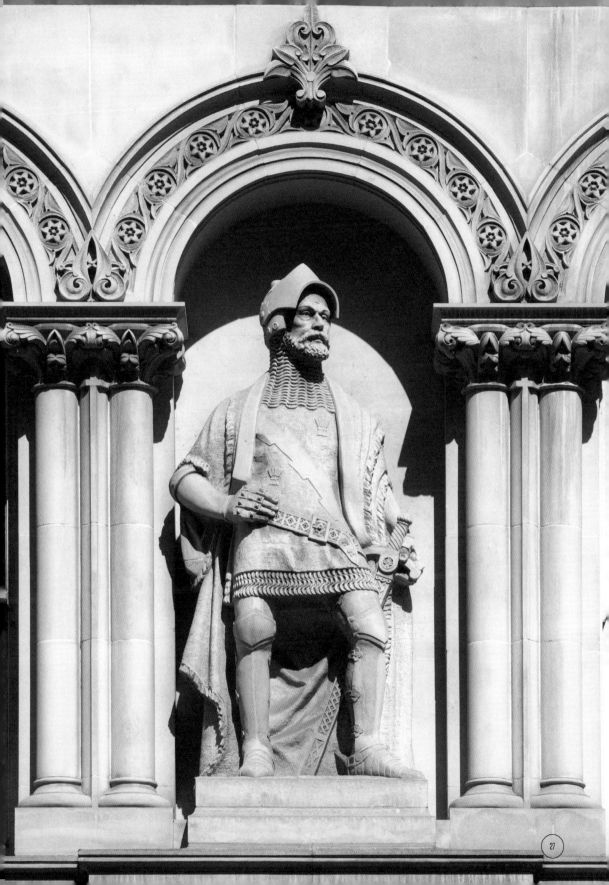

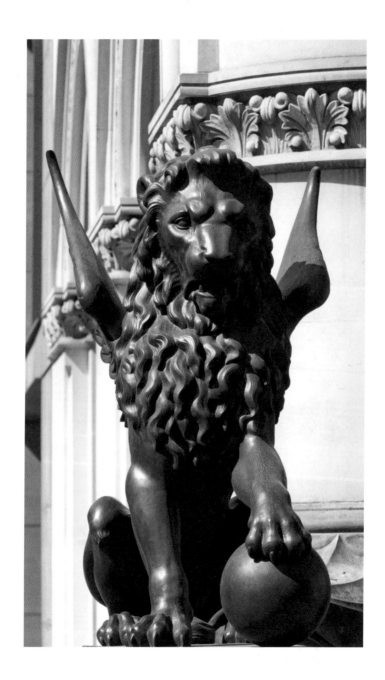

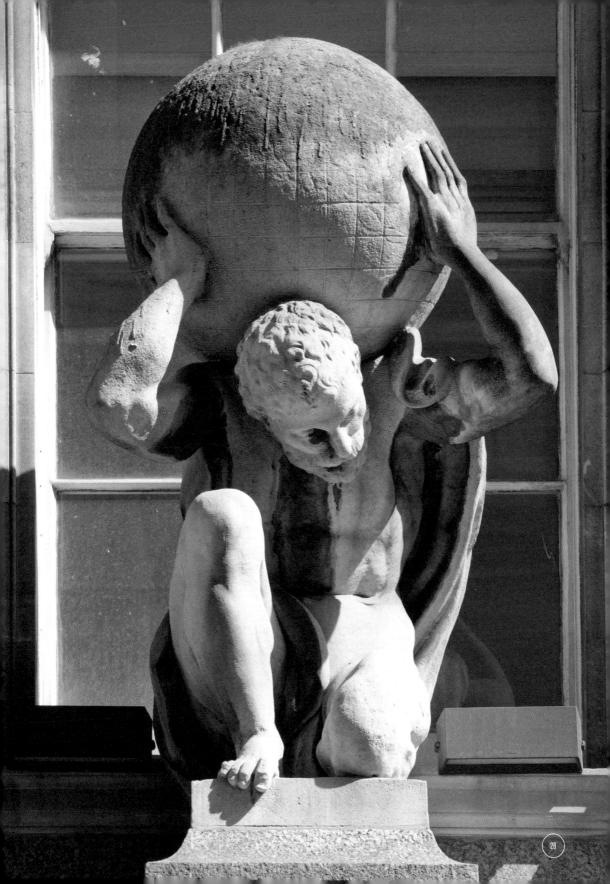

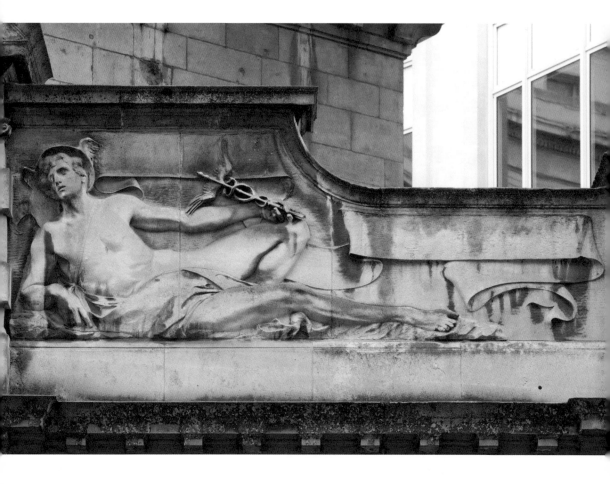

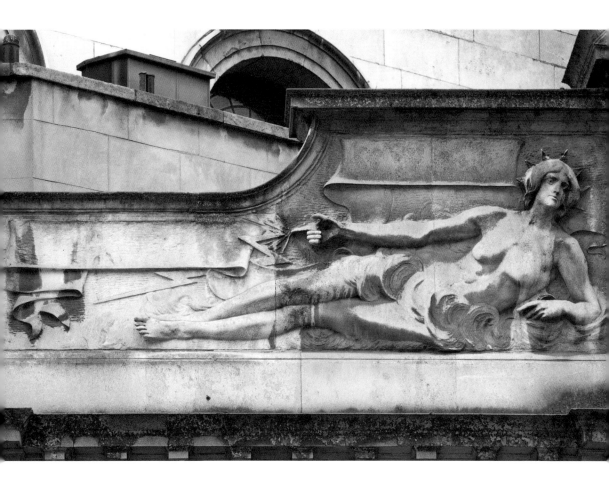

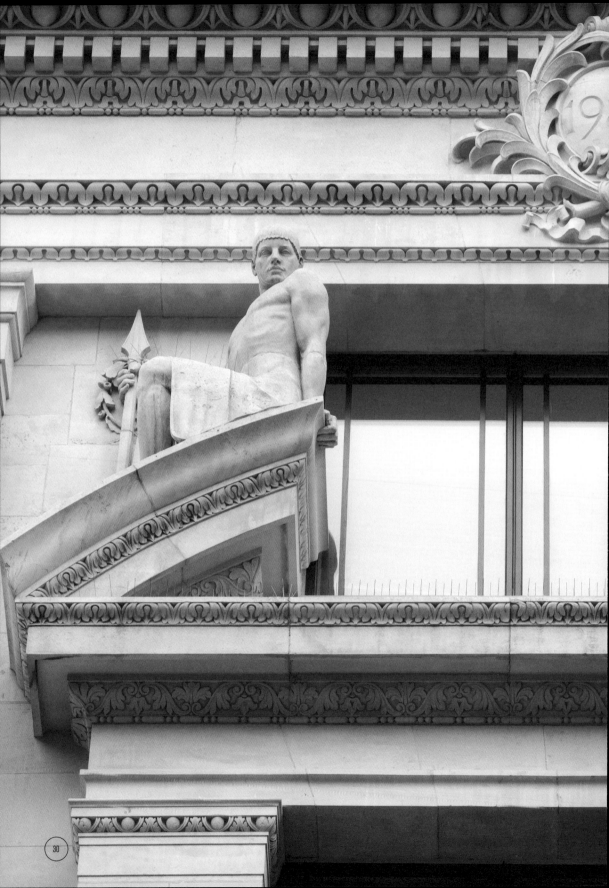

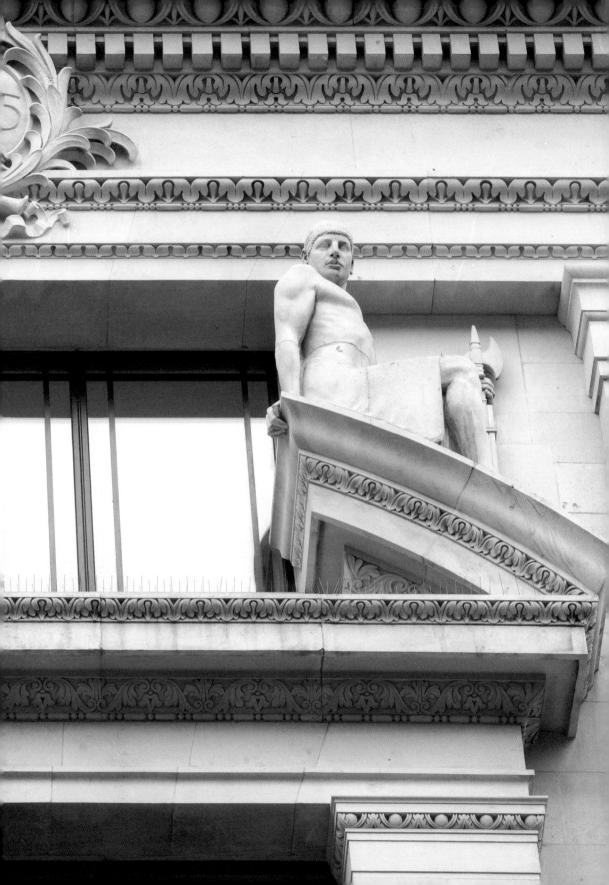

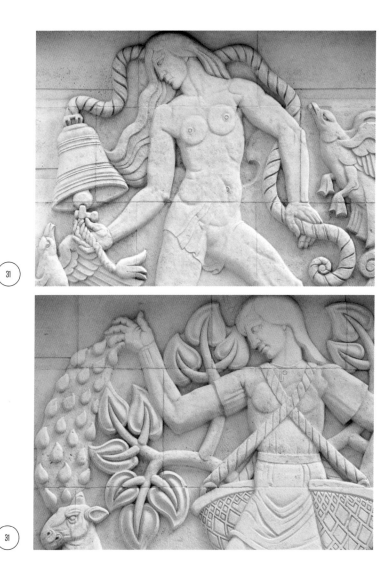

31

31

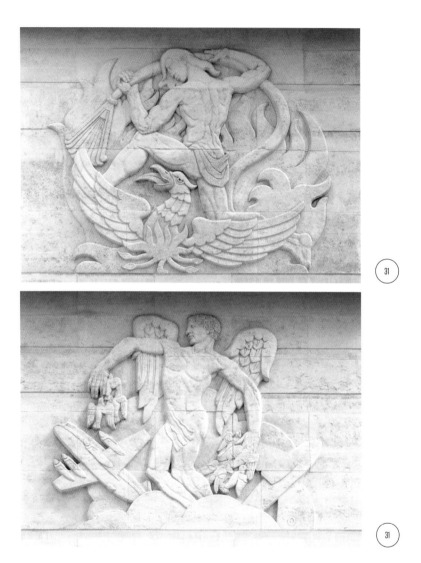

31

31

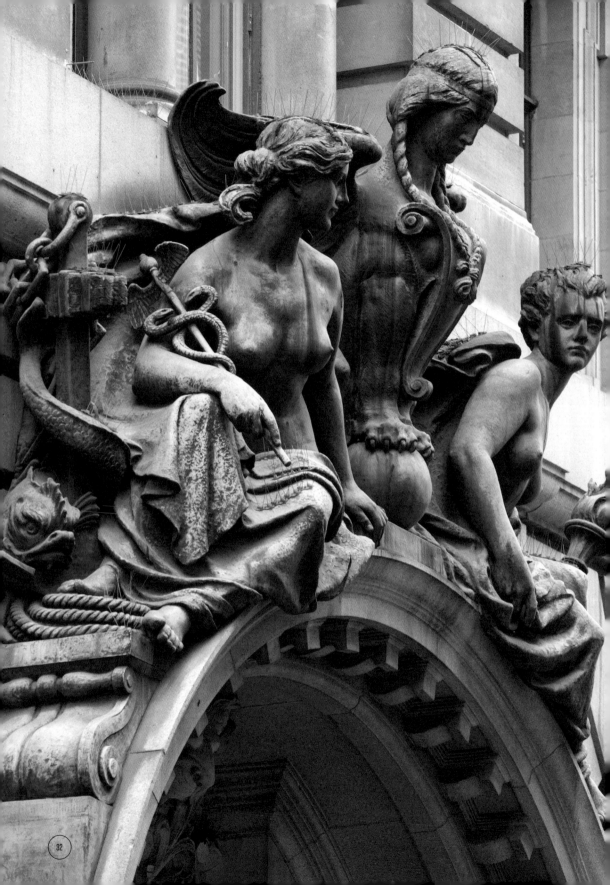

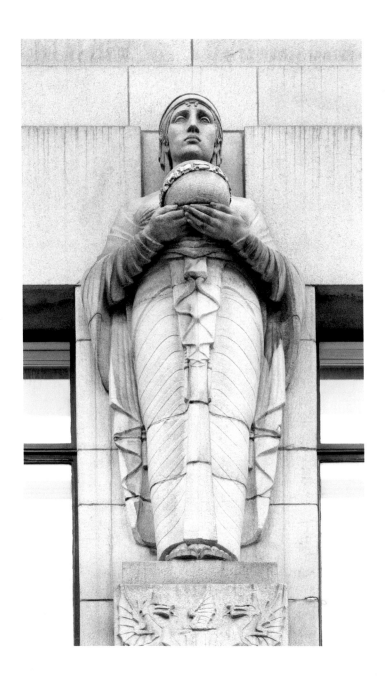

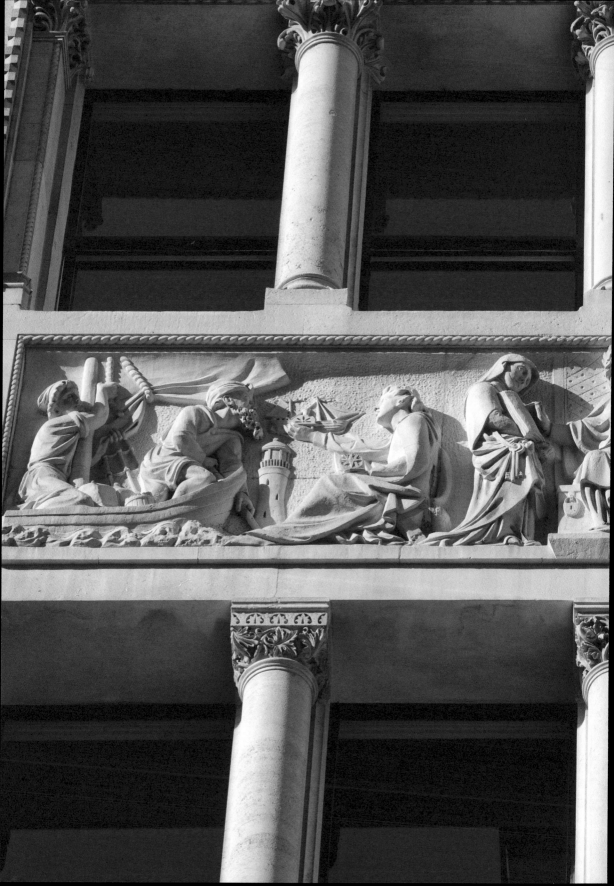

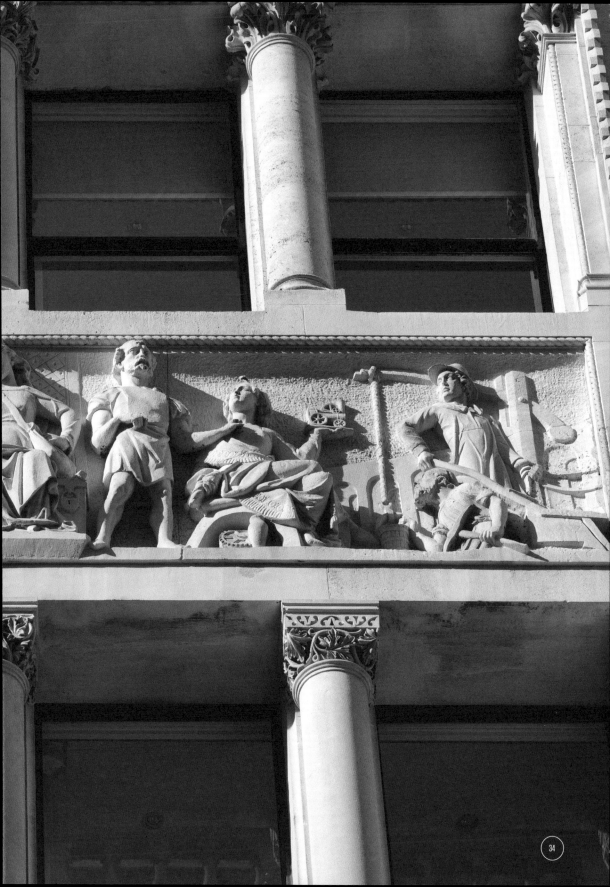

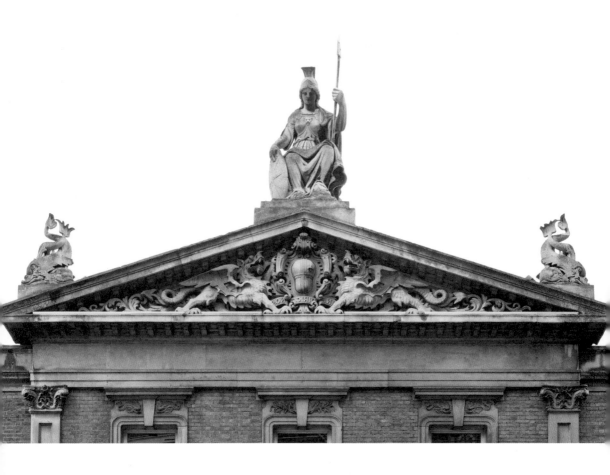

The City of London Trampling Envy

(overleaf)

Clare Pollard

She feasts on the venison, sirloin and capons,
the cygnet, the pleasure-gardens and the pub,

the syllabub, peacocks, the gauzes in Cheapside,
muffs from the torrid zone, coffee and tea.

A stroller, she tumbles the wares and buys baubles,
chocolate and indigo, rattles and gossips,

without one word for the sweated employment;
the boy who sings: *rabbits hanging on my pole,*

who will buy my fine rabbits? The girl
who cries: *Diddle diddle, dumplings, ho!*

She buy love songs, a fistful; sweet china oranges,
sweeter than sugar, and pineapples shipped

from strange lands, turtle-soup and the dolphin-shaped ices
that melt into slurry, the pastoral-scenes

spun from sugar. She wolfs down cheese-wigs and gumballs,
and fine silver eels for five shillings a basket,

porcelains, songbirds and fans from the Indies,
copper-laced sweets and the alum in bread.

O Plenty is pouring, the Thames is intensely
relaxed about wealth, who are you to cast doubts?

To mention the slaves or the children who labour?
The jealous disgust her. My dear, you watch out.

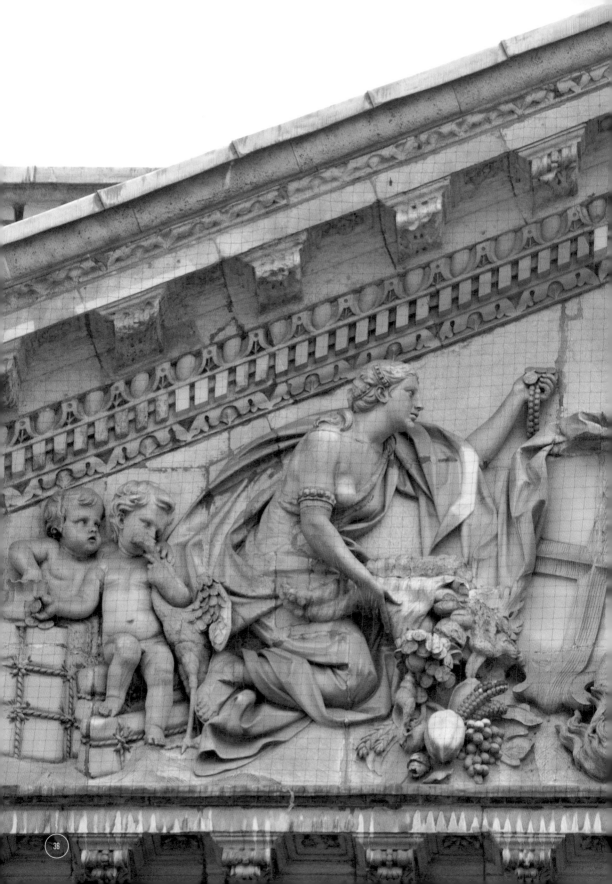

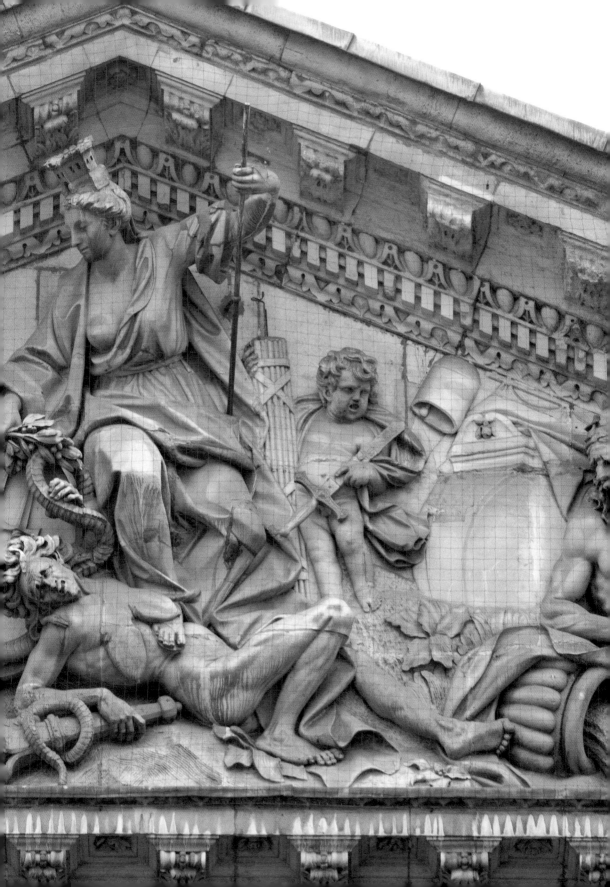

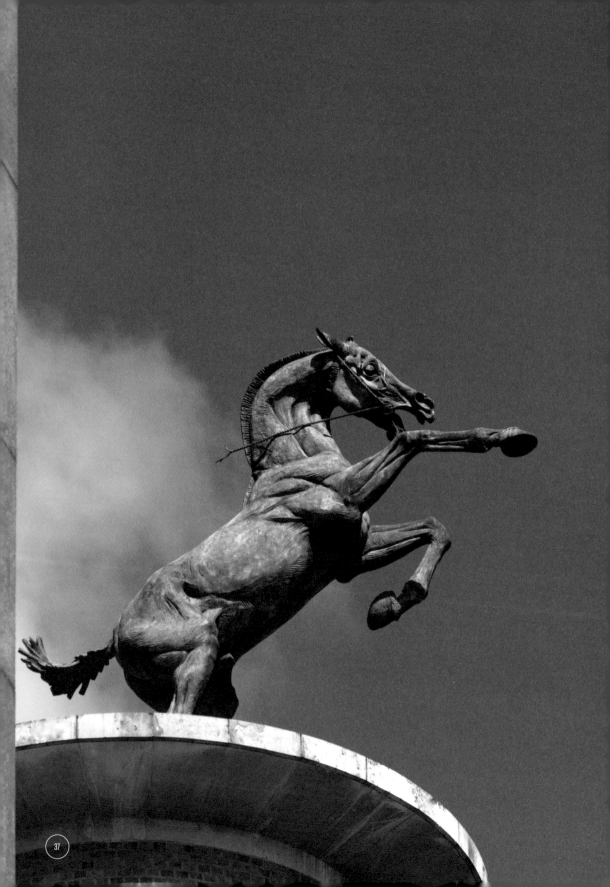

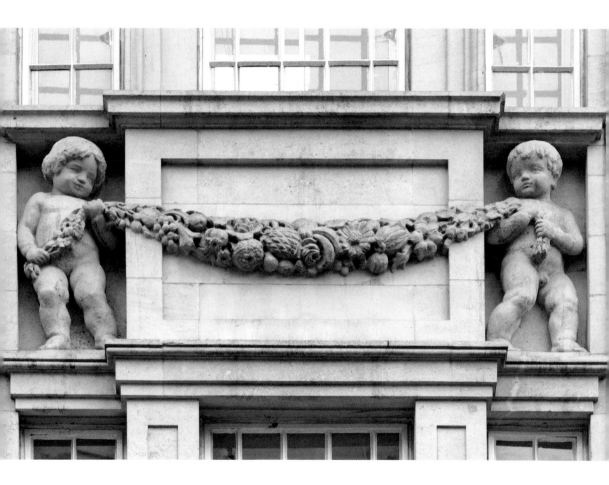

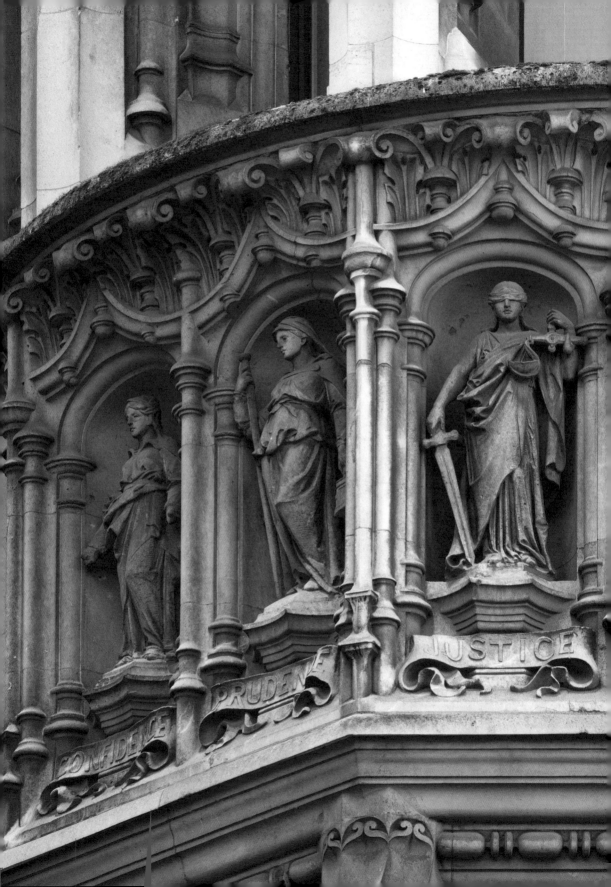

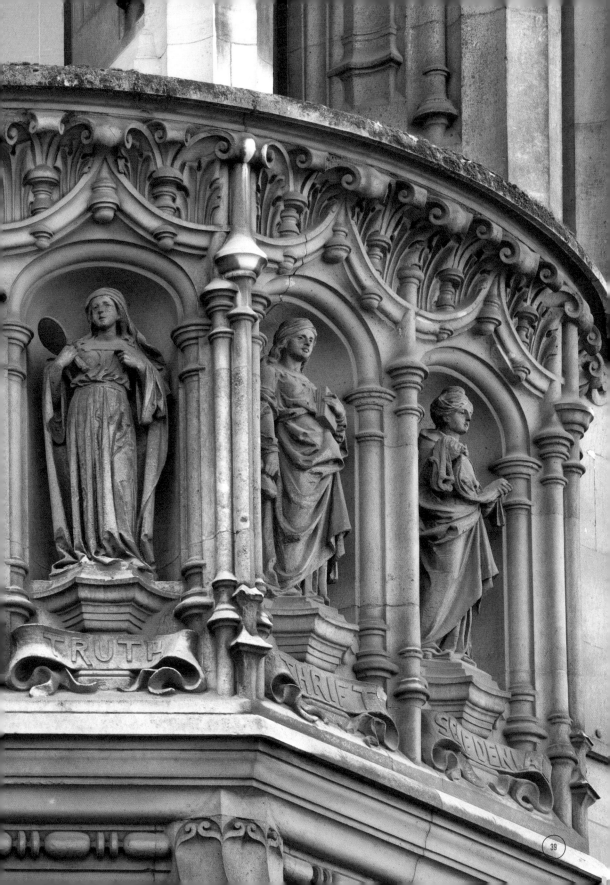

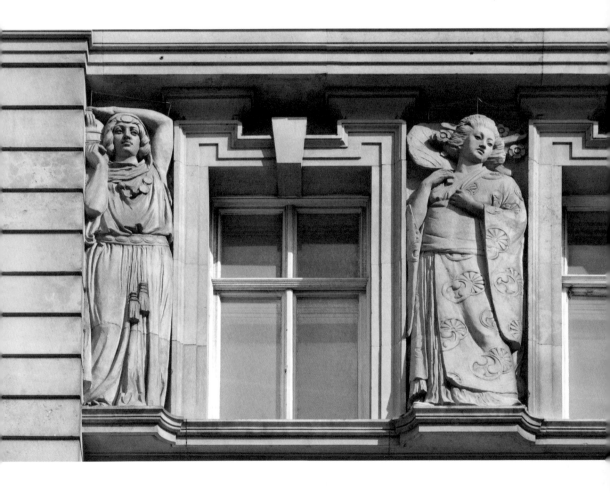

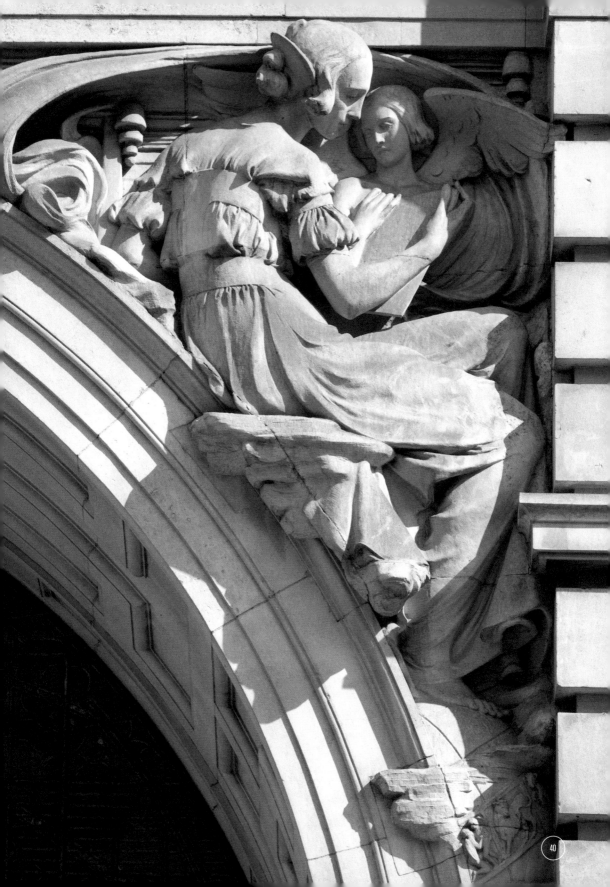

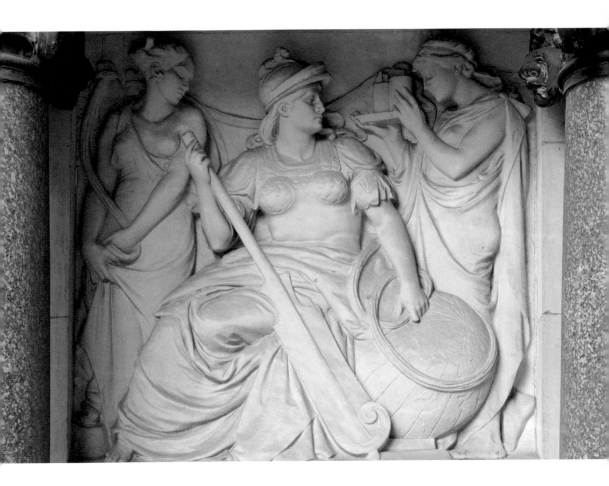

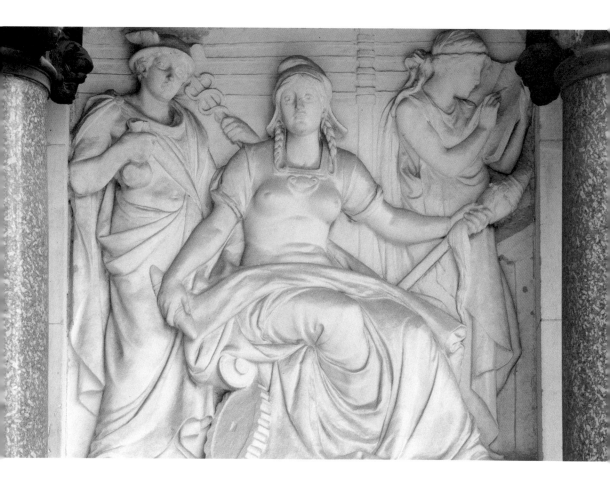

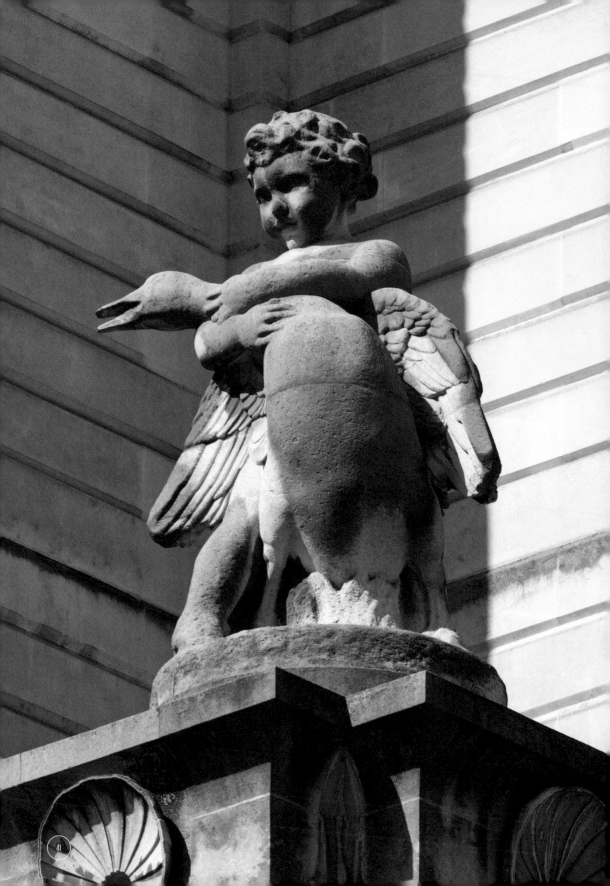

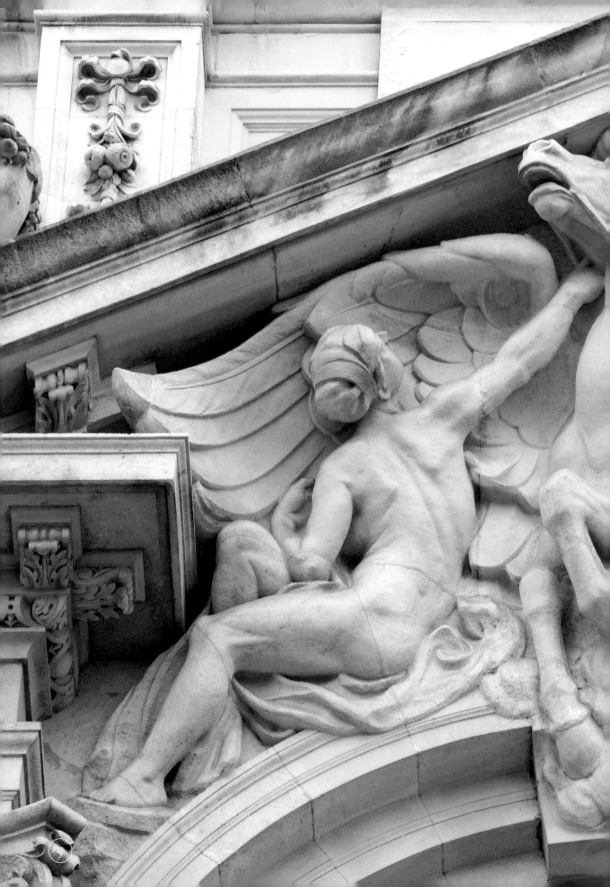

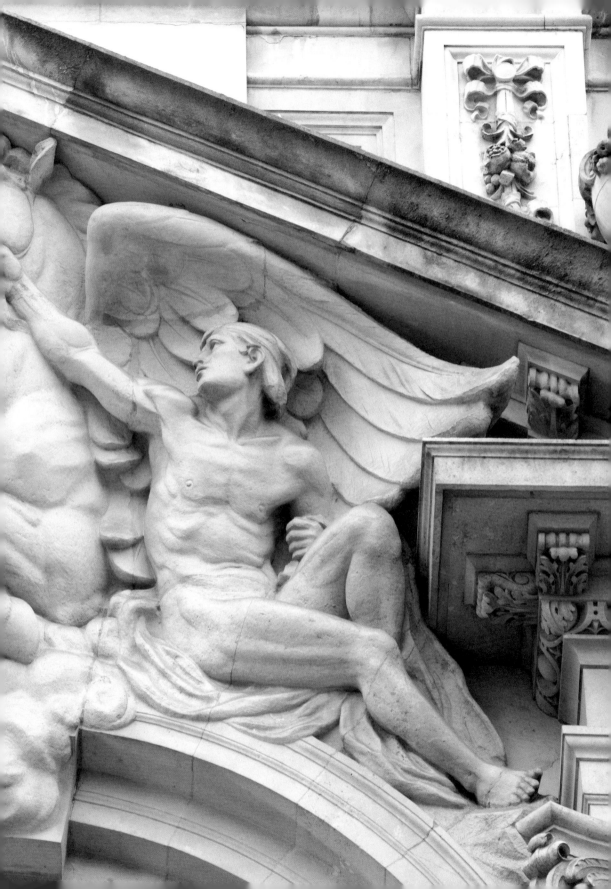

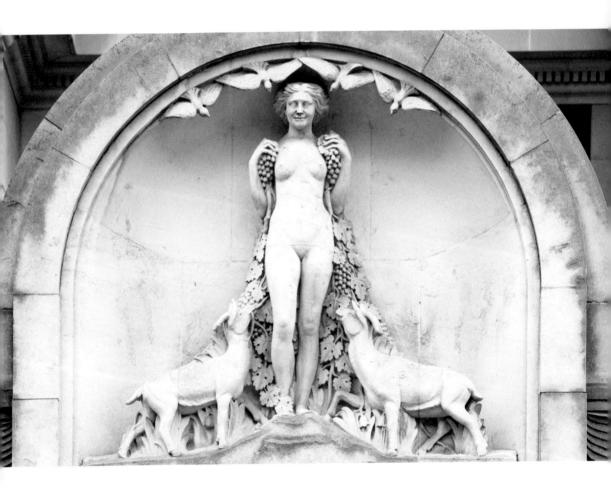

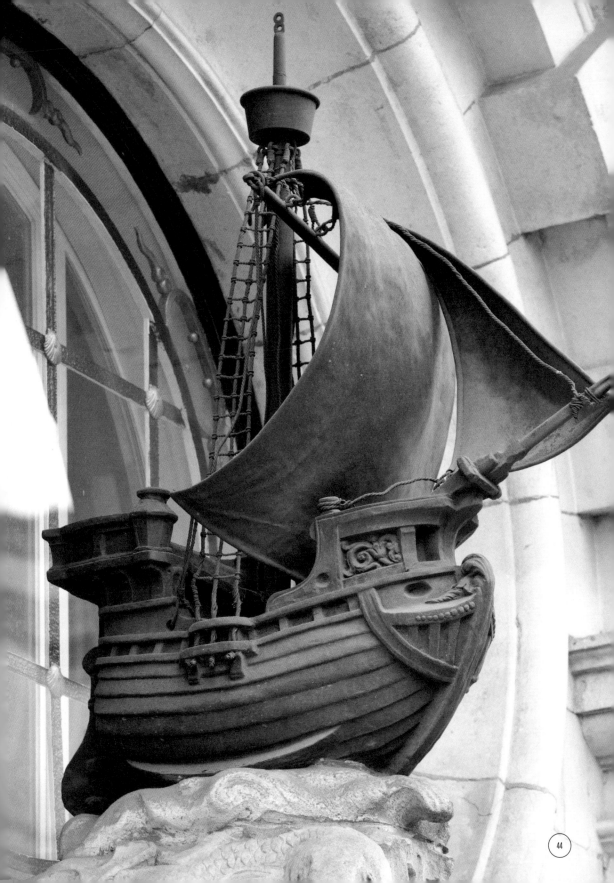

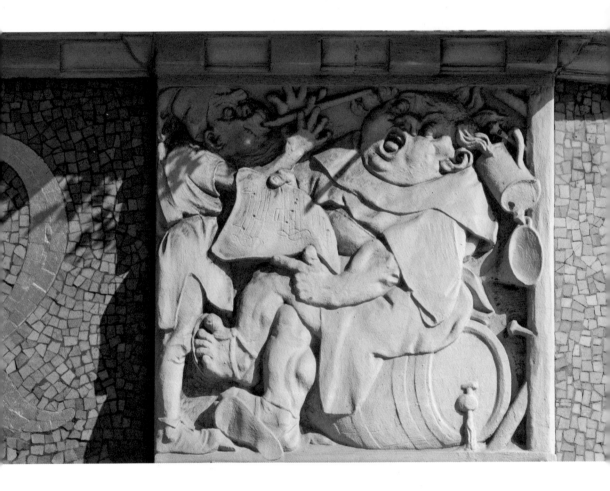

The Nursery Rhymes

Clare Pollard

On Queen Victoria Street,
in every face I meet,
in blasts of winter's breath,
I see the marks of age.

And adults know the rhymes
that once seemed comforting
are always about death.
The rings o roses seep.

In and out The Black Friar
is where the money goes.
In the pub it's piping loud
and warm as swaddling clothes.

They wet each head with drink
as if we could start blank,
forgetting Bloody Mary's
cockleshells can torture;

that the Muffin Man of Drury Lane
baits children to his shop;
that blackbirds will peck
the maid's nose off;

that bricks and mortar will not stay;
the dish will run away
and the Great Bell of Bow
does not know.

Here amongst the dregs
Humpty is a stone egg.
Brandy boiled with ale
makes you feel unbreakable.

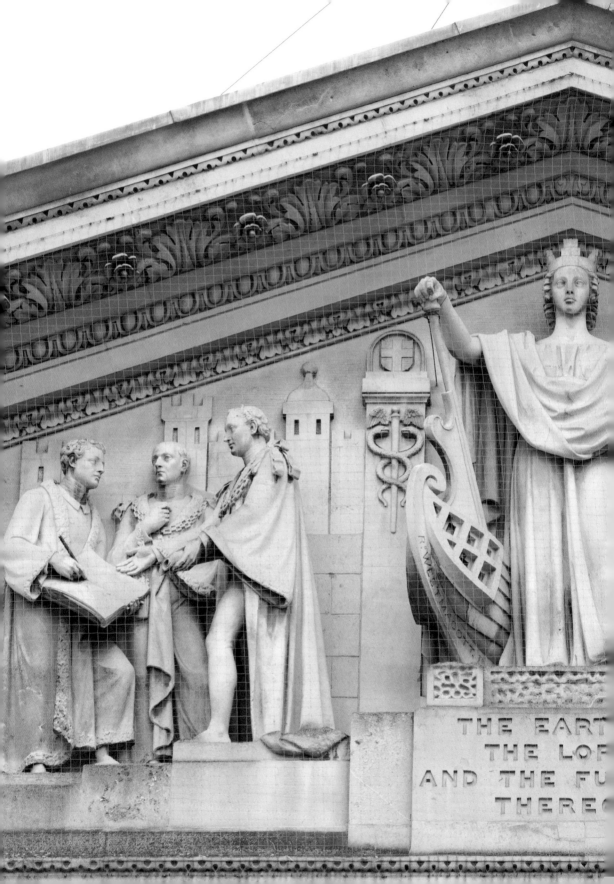

THE EART
THE LOF
AND THE FU
THERE

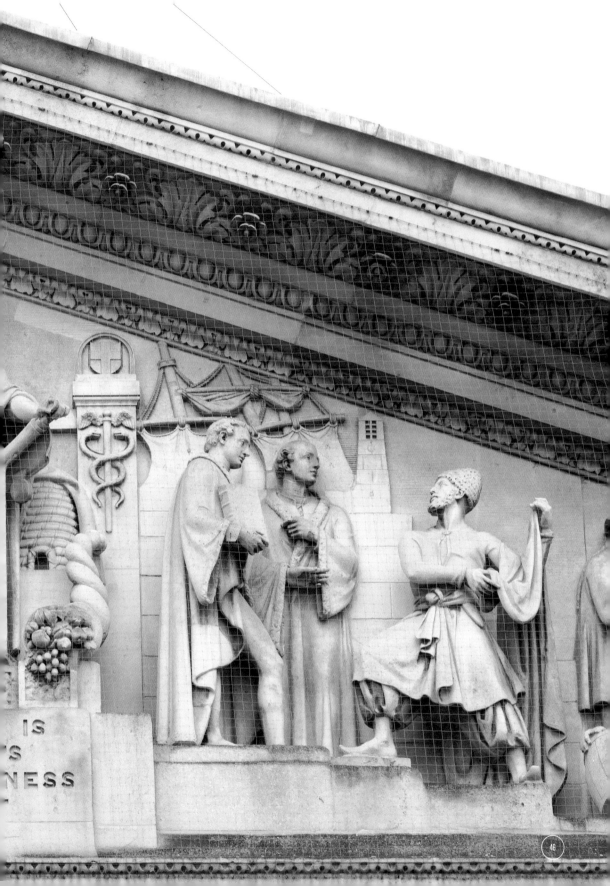

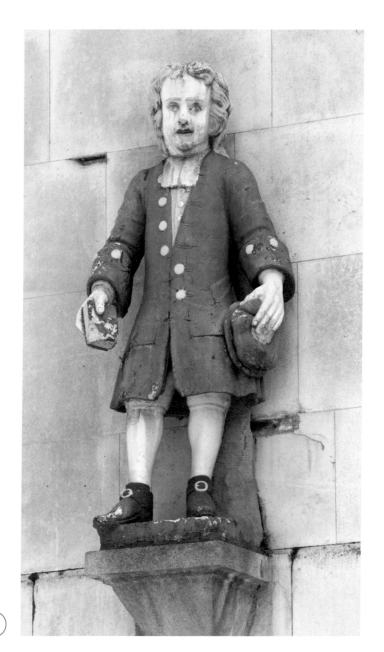

Charity Boy, St Andrew Holborn

Clare Pollard

My mother died in childbirth.
The angels took her soul
but I was dressed in sky-blue,
given gruel.

Charity taught me counting,
charity taught letters.
Up here I've counted matchgirls
in the gutters,

boozy Bloomsbury dinners,
and angry suffragettes.
Up here I have sounded out:
ATOS, Pret.

The truant in blue trainers
has had no food tonight;
the girl looks for a shelter
without spikes.

Look up: I watch you choosing
what you will and won't give.
I see from high, as Christ does,
who'll be saved.

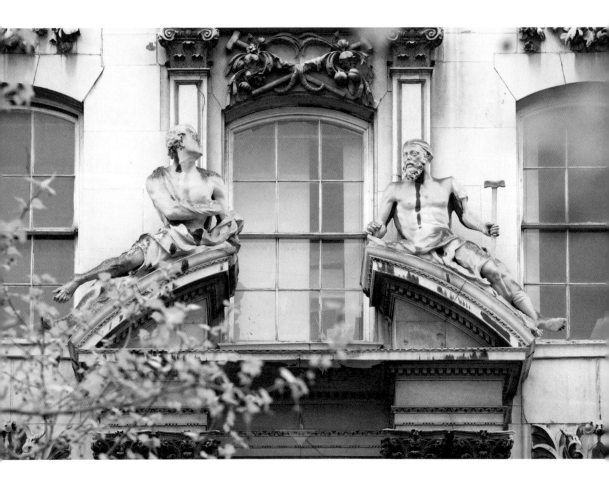

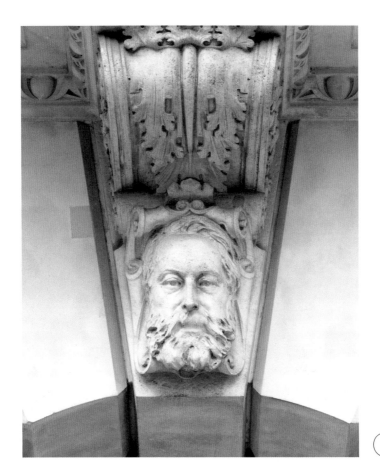

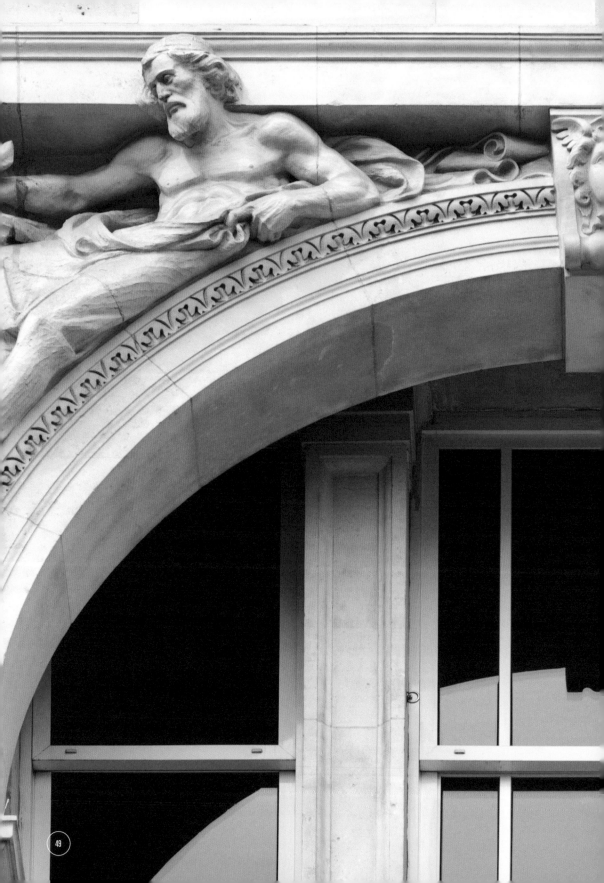

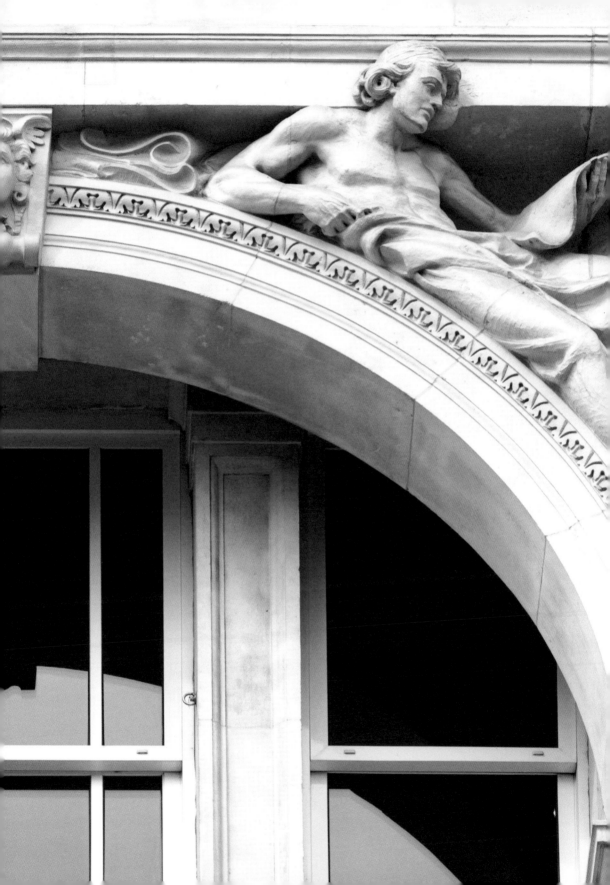

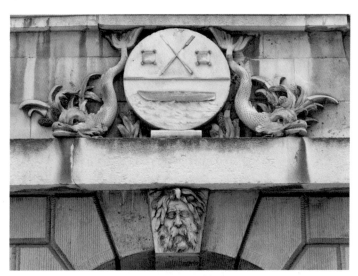

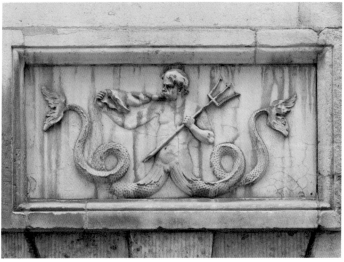

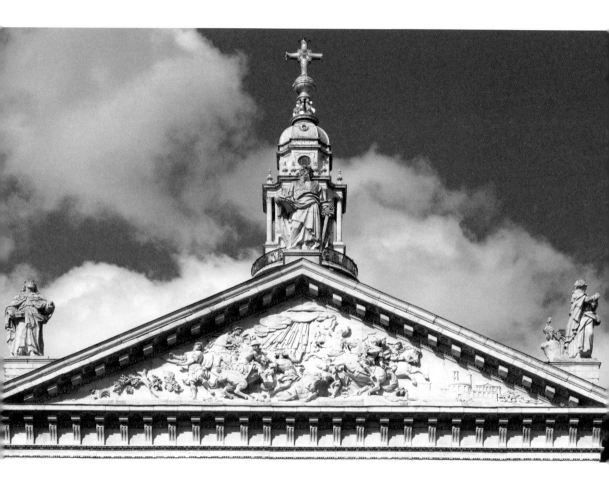

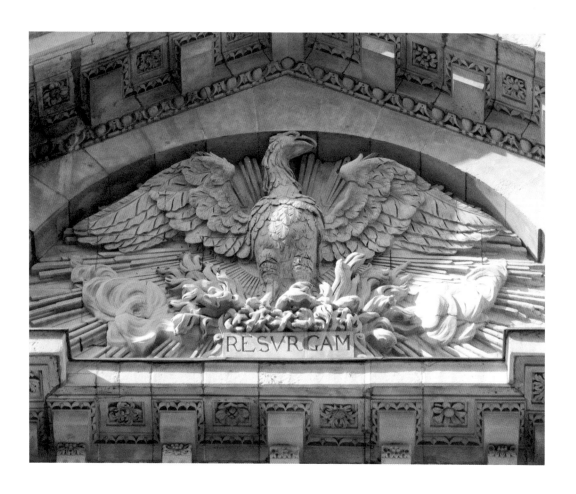

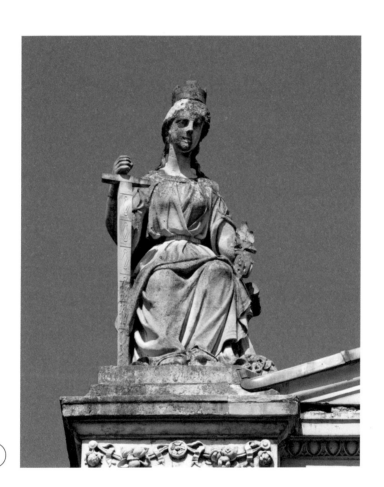

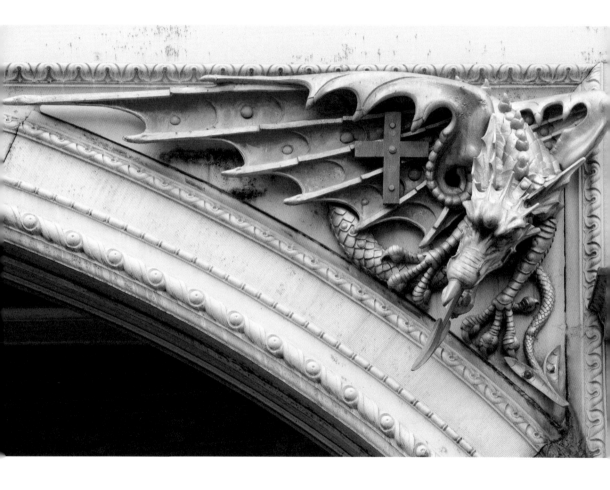

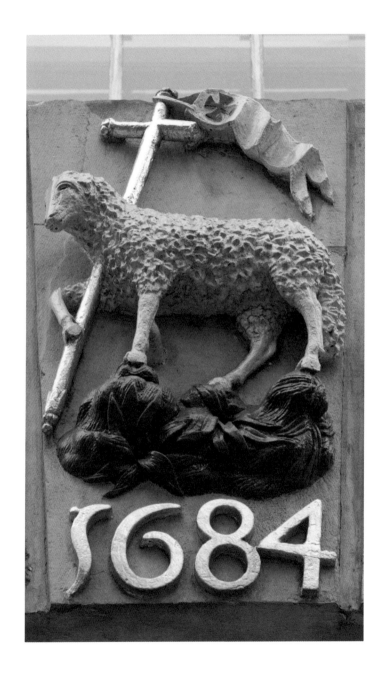

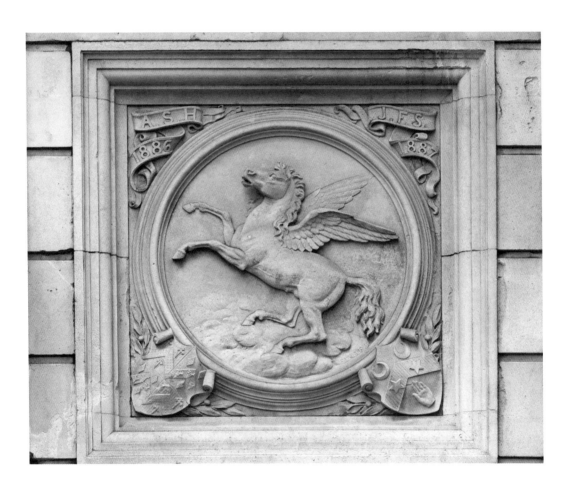

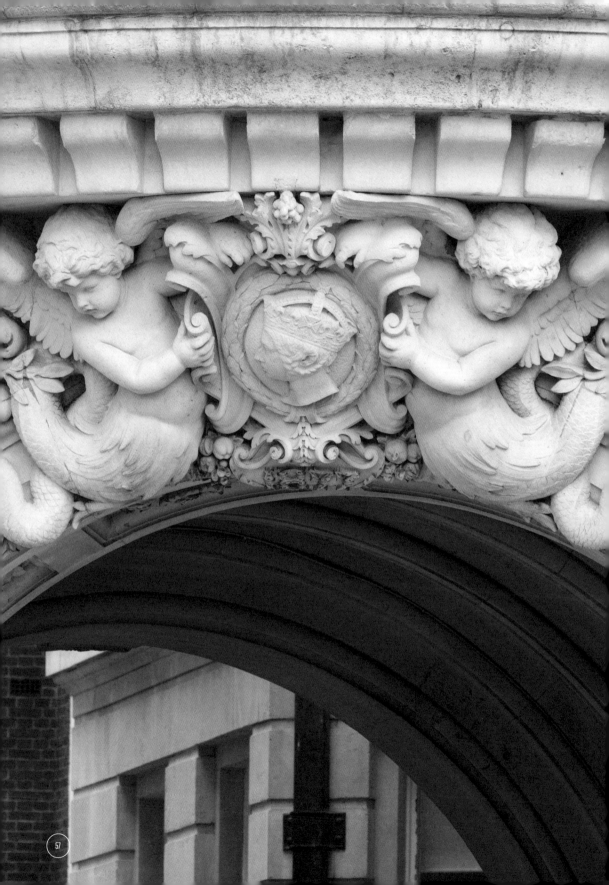

Queen Victoria and the Winged Merchildren

Clare Pollard

Victorian children were innocent,
all orphans, sold or shinning up
chim chim-in-eys soot-smudged,
or scuttling beneath vast looms.

The pretty pressed faces to toyshop
windows, or saved old widowers,
or posed phantomwise for photos
as if coquettish with caterpillars.

They always said their prayers
for goose and to never grow up
and were usually lame
but improving each shining hour

until they died before adulthood,
waters closing like a pea-green veil,
fading, gentle and noble as Nell -
bless them, each and every angel!

Bless their souls, wings and tails!
Queen Victoria thought her nine
newborns ugly, but her subjects
were sentimental for little monsters.

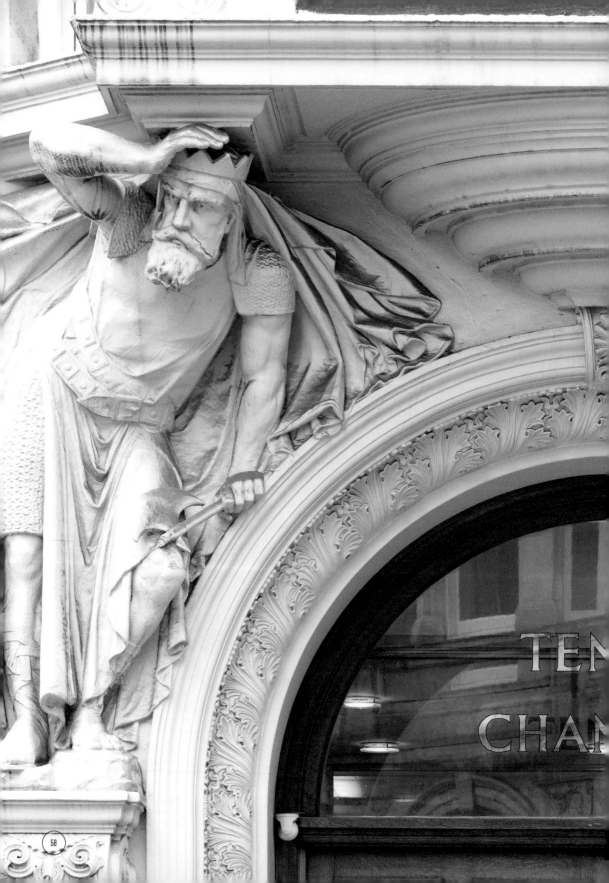

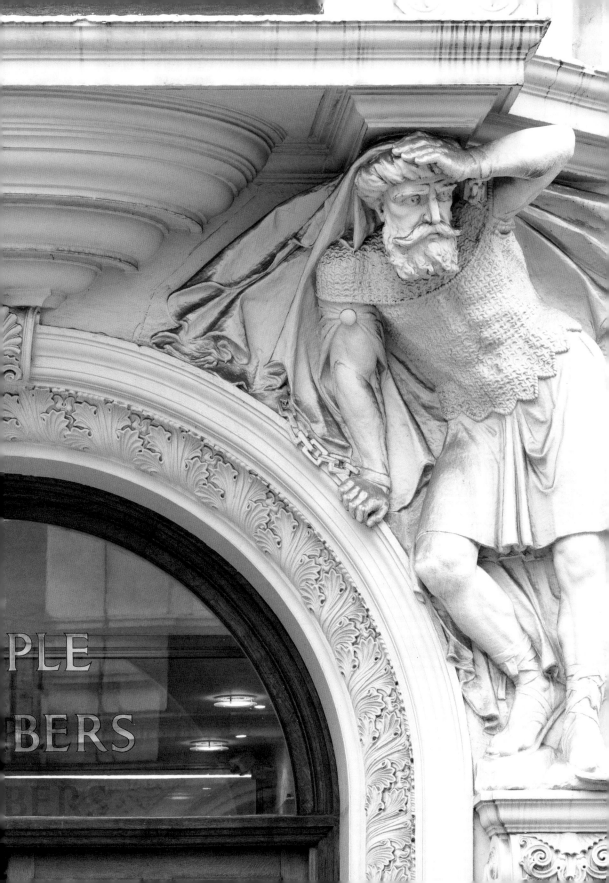

PLE

BERS

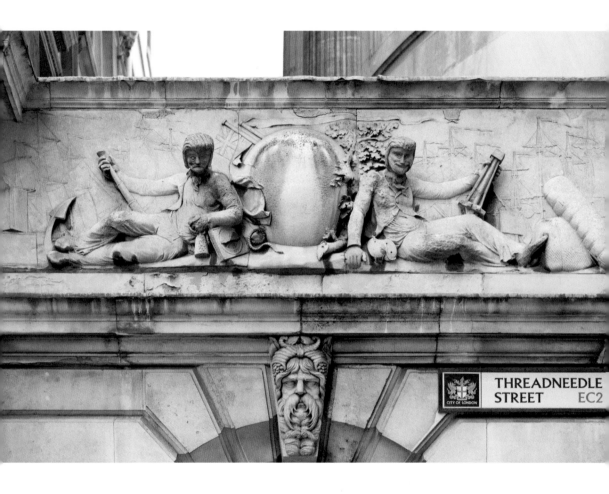

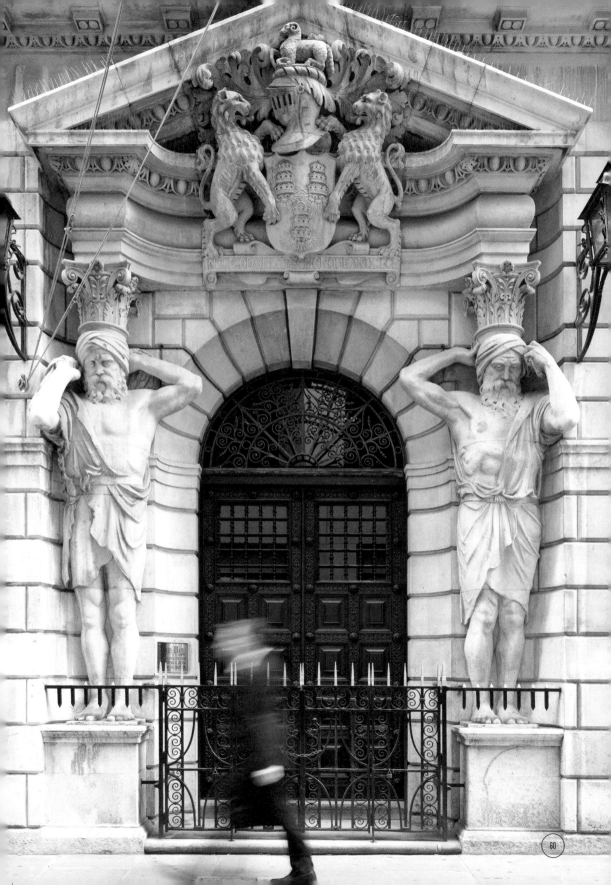

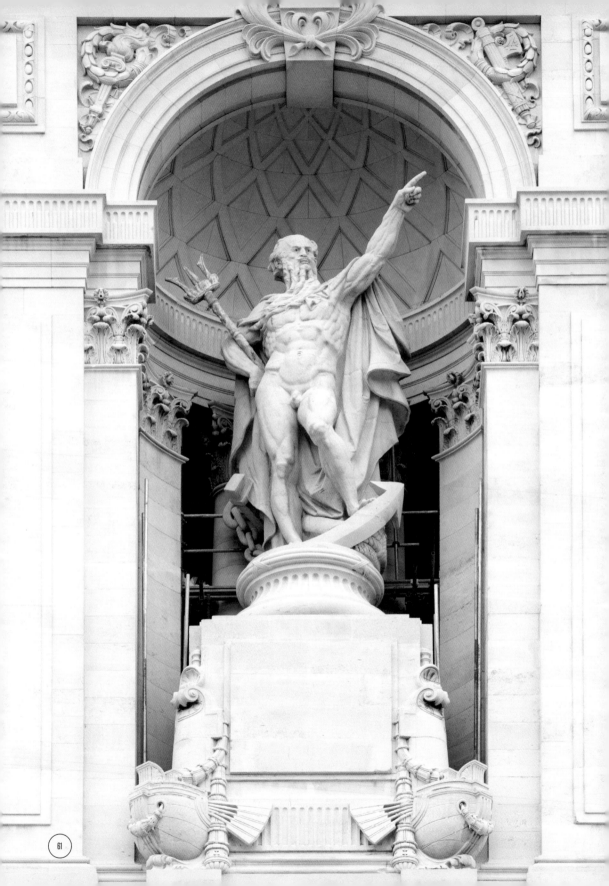

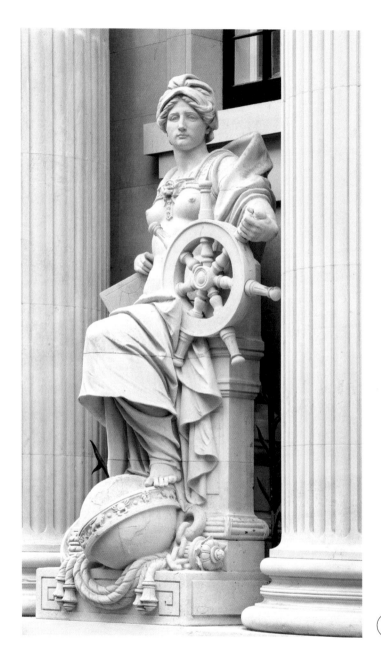

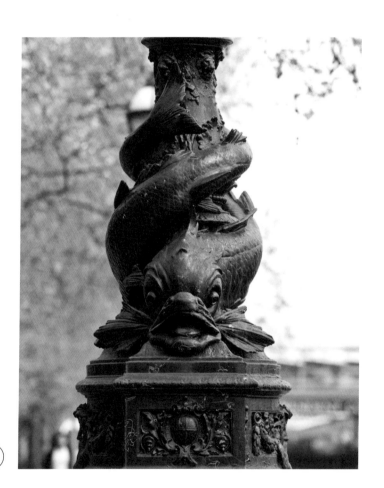

62

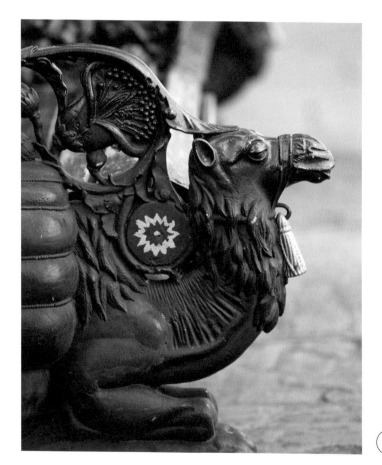

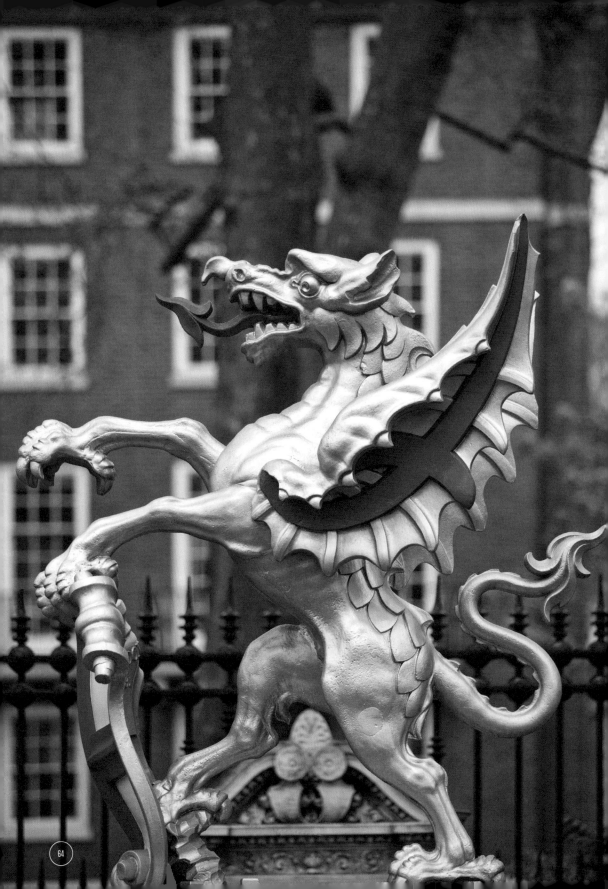

Emblematic Dragons

Clare Pollard

Map-makers printed HERE BE DRAGONS,
and so people believed in dragons.

Beneath Fleet Street a hidden river
trickles in darkness like rumour.

Since its first newspaper, The Daily Courant,
the currency has been insinuation -

all representations of menacing abominations
are mythical and/or on the payroll.

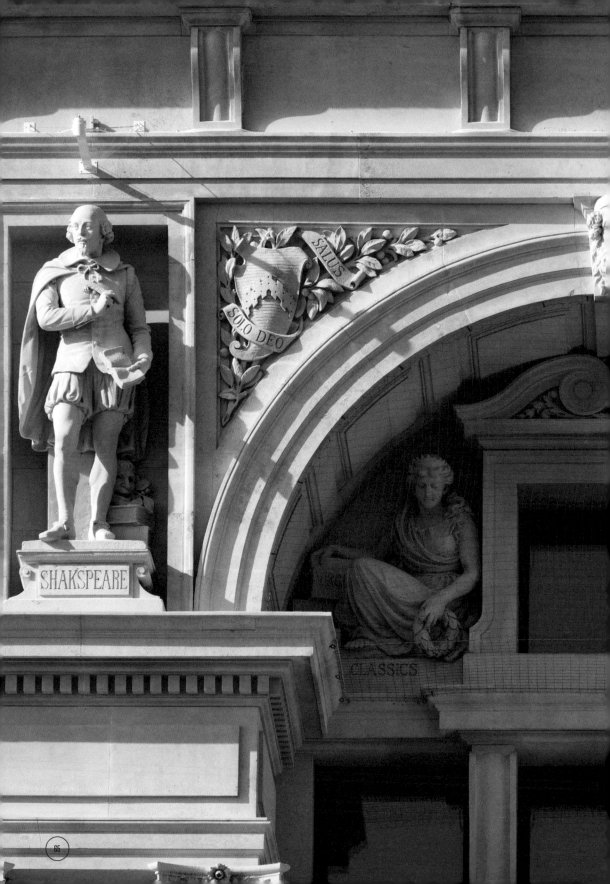

SALUS

SOLO DEO

SHAKSPEARE

CLASSICS

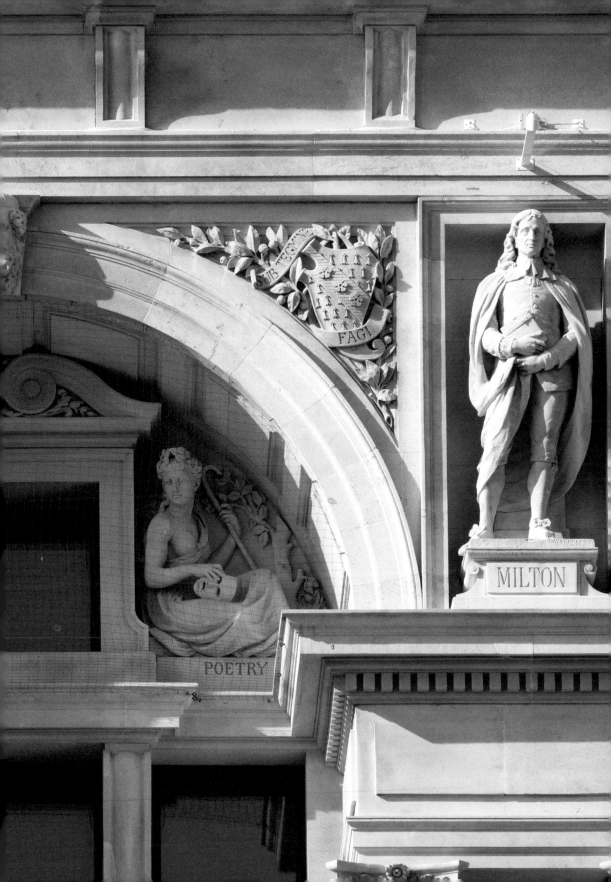

SUB TEGMINE
FAGI

POETRY

DAVID WHEELER SC

MILTON

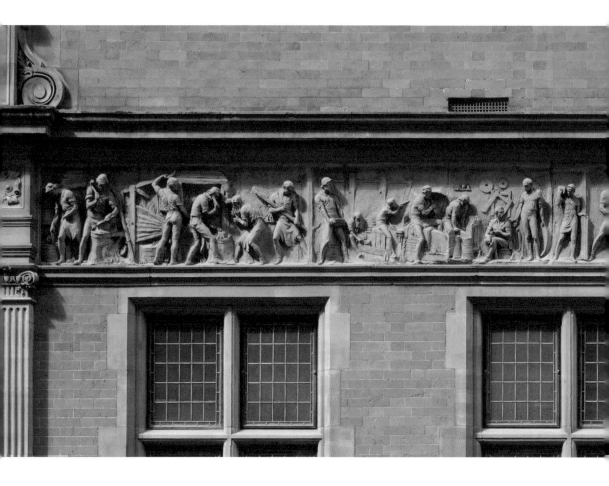

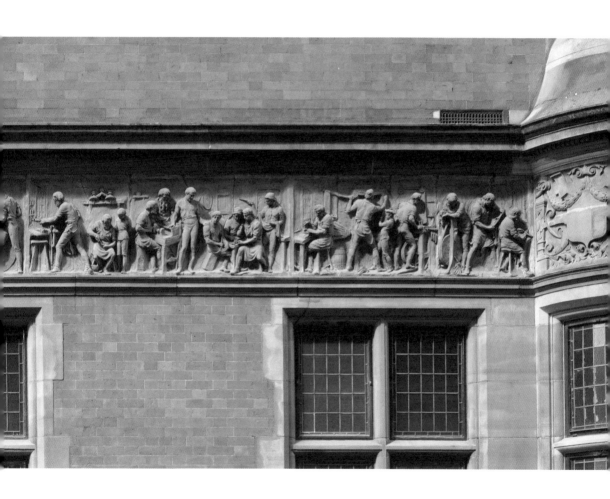

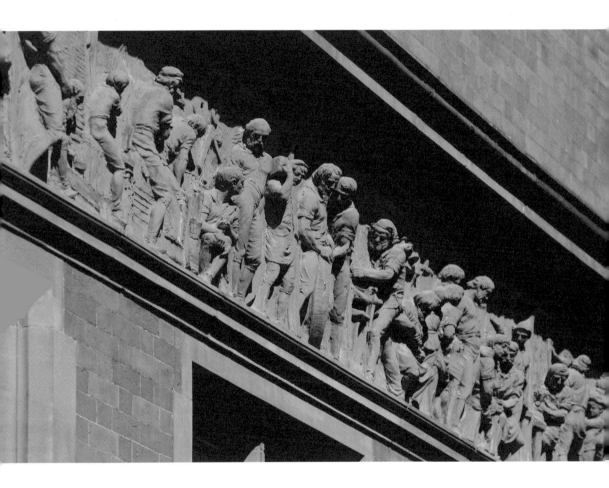

P. LINDSEY CLARK Sc. 1926

The Bakers

Clare Pollard

After William Blake

In East London such bakers bake bread!
In the windows the grandmothers sit
making pillowy *pide* to rise
and be meat-striped above charcoal pits,

naan are flung to the tandoor's fierce edge
and from first sun, which flecks them like flour,
women knead at the new, tender dough,
proof the *beigels* we need at late hours.

See the punters swerve in from wet streets
for the *lox* or the *lamachan*, bite
and find peace where the emptiness was,
as the glazed dark is sliced up by lights.

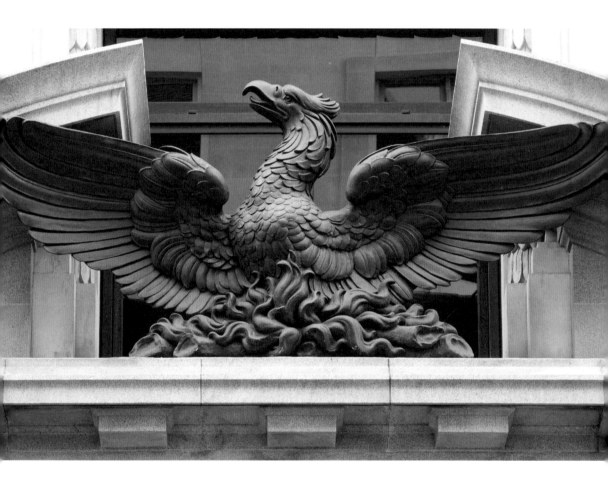

REFERENCE

1. All-Hallows Church, Barking (North Porch), (1892-5)

St Ethelburga, Virgin and Child

Sculptor: Nathaniel Hitch

Architect: J.L Pearson

The figures of St Ethelburga, Virgin and Child and Lancelot Andrewes, stand over the porch of All hallows, where they were installed as part of a restoration project in the 1890s; they have survived despite serious damage to the church during the Blitz. The three figures together represent the three periods in the history of the church; the primitive, the medieval and the modern.

2. Bank of England, Threadneedle Street, Central Arch, (1928-31)

Carayatids and Telamones, The Lady of the Bank, Ariel (Spirit of the Winds), The Lothbury Ladies

Sculptor: Charles Wheeler

Architect: Sir Herbert Baker

These two female and four male figures are carved into the outer pillars of the building: while the females each carry a cornucopia, representing productivity, the male figures have all the control, holding keys, which demonstrate the safe custodianship of the Bank.

Presiding over the building is Charles Wheeler's Lady, matriarch of the Bank of England, who occupies the central pediment of the building. Direct-carved, and seated on a globe next to a pile of coins, she replaced the former Bank of England building's figure of Britannia in 1929.

Atop the Bank is a figure referred to as both Ariel (an allusion to The Tempest) and the Spirit of the Winds. Created between 1935-37, this figure certainly occupies an exposed spot! While a motion to allow the figure to rotate in the wind failed, the decision was made to gild the Spirit instead. Seen to be standing on 'air', the figure appears to be flying above the Bank, apparently symbolising the Bank's global strength.

The Four figures, known as the Lothbury Ladies formed an addition to the Bank in the 1930s, though there was some concern that the imagery they portrayed was not entirely appropriate to the economic climate. Two of the women carry cornucopias and coins, representing the Bank's prosperity, while the other two hold children, to symbolise future hope and productivity.

3. National Westminister Bank, 15 Bishopgate, 'The Gibson Hall', (1864-5 and 1878)

Parapet figures

Sculptors: J.Hancock, Felix Martin Miller, Henry Bursill, C. Mabey

Architect: John Gibson

These plaques, originally designed for the National Provincial Bank of England, represent various industries and areas of the United Kingdom. Manchester can be seen standing next to a kneeling Afro-American, who is clasping some cotton; Birmingham holds a sledge-hammer; Newcastle holds a saucer; Dover stands with a shell, paper and a horn; Wales depicts St David, with two others, holding his sword; while England (pictured), is represented by St George, Britannia and Navigation. All four plaques were added in 1864-5. Shipbuilding, holding a model ship and a hammer, and Mining, also holding a hammer as well as a lamp, were added in 1878.

4. Bracken House, Cannon Street, (1955-9)

Zodiacal Clock

Sculptors: Frank Dobson and Philip Bentham

Architect: Sir Albert Richardson

This clock stands over the main door of Bracken House, with an outer ring bearing the months of the year, and an inner ring containing the signs of the zodiac. In the middle is a gilt bronze sun – look carefully, and you will see the happy face of Winston Churchill, rather than Apollo, peering out from its centre.

5. Old Bailey, Newgate Street, (1905-6)

Allegorical Figure of 'Justice'
Allegorical Figures. Pediment Sculptures of
Fortitude, Truth and the Recording Angel

Sculptor: F.W Pomeroy

Architect: E.W Mountford

Overseeing events in the Old Bailey is
Justice, a 3.5 metre gilt bronze figure with
arms outstretched, standing on a globe.
Swift to exact retribution, she holds a
sword and scales; yet unusually for this
period, she does not wear a blindfold.
Over the main door of the Old Bailey
sit three female figures, who serve as a
reminder to those who enter of both their
own and the Court's role: Fortitude, who
wields a huge sword; the Recording Angel,
who is writing on a scroll; and Truth, who
is gazing at her own reflection.

6. 29-30 Cornhill, (1934-35)

Pediment and Door Reliefs

Sculptor: W.McMillan

Architect: W.Curtis Green

A naked man reaching out to Pegasus
reminds us here of the motto to 'take time
by the forelock', while the seated female
figures are reminiscent of the Lothbury
Ladies (see no. 2), with one holding a
child, and the other clutching a cornucopia,
which is overflowing with fruit and flowers.

7. St Michael, Cornhill, (1856-8)

Decorative Carving of St Michael disputing
with Satan

Sculptor: John Birnie Philip

Architect: George Gilbert Scott

This rich and lifelike carving, mixing classic
and gothic elements, was added to the
church porch during a series of restorations
between 1856 and 1860, and depicts St
Michael and his angels overcoming Satan
and his followers.

**8. Banco Ambrosiano Veneto (Originally
Union Bank of Australia), Cornhill, (1896)**

Romantic neo-Grecian Figures.

Scuptor: Henry Pegram

Architect: Goymour Cuthbert

On this neo-Grecian building stands a row
of six Persian figures supporting a cornice;
there are three differing designs, each in
duplicate. One old, one middle-aged and
one young, the Persians stand at around 2.5
metres high.

9. Britannia House, (1912-20)

Personification of Rail and Sea Travel

Architect: Arthur Usher

These two figures sit above the doorway
to the building. The woman carries,
appropriately, a miniature steam train, and
sits next to a train wheel, and represents
rail travel; the man holds an anchor and
leans on the prow of a boat. With such
transparent imagery, it is unsurprising that
this building was once the office of the
London, Chatham and Dover Railway.

**10. Lloyd's Register of Shipping,
(1899-1901)**

Emblematic female figures, Carving over
doorway arch, Allegorical panel

Sculptors: George Frampton
and J.E Taylerson

Architect: T.E Collcutt

On the outside of Lloyd's Register of
shipping stand five maidens, each carrying
a model boat. The motif of the maiden
appears across the building. Following the
success of Lloyd's List, which detailed ships
the cargoes they carried, premises were
sought to house the operation, which T. E.
Collcutt was recruited to design.

The importance of Cardiff and
Southampton to the company is
demonstrated by the presence of their
coats of arms, which lie over a window,
surrounded by more maidens holding
navigational tools and two cross-sections
of engines.

A carved panel representing both the
abundance and the risks of trade can be
found over the left door. In the centre
stands a scantily clad male figure in front of
a globe, wearing Mercury's winged hat and
carrying a galleon sitting on a globe, as well
as the caduceus. At either side are women
wearing foreign clothing and carrying
boxes, weapons, a tusk and corn; at their
feet is a wealth of exotic fruit.

11. Britannic House, Finsbury Circus, (1924)
Architectural Sculpture of Indian water-carrier

Sculptor: Francis Derwent Wood

Architect: Edwin Lutyens

Originally the offices of the Anglo-Persian Oil Company (which later became BP), this building was completed in the mid-1920s. The connection to the East can be found in figures discreetly placed on the building. This Indian figure, wearing a turban and pouring water from a sack on his shoulder, stands on the centre of the façade.

12. Britannic House, (1921-5)
Decorative keystones

Sculptors: Messrs Broadbent & Sons

Architect: Edwin Lutyens

These lavish keystones can be found across the building, depicting human heads looking out surrounded by a wreath of flowers and plants, representing the worlds of Empire and commerce.

13. Temple Bar Memorial, (1879-80)
City Dragon Statue, Queen Victoria, Edward VII

Sculptor: CB Birch, JE Boehm

Architect: Horace Jones

Standing atop the Temple Bar Memorial is this bronze dragon holding the City arms. Once on the outskirts of the City, Temple Bar had been a boundary marker since 1672. The building of the memorial was not too popular with letter-writers to *The Times* and was blamed for obstructing traffic in the mid-nineteenth century.

On the south side of the Memorial stands Queen Victoria, who died in 1901. This particular memorial, by JE Boehm, commemorates a very specific occasion, when Victoria visited the Guildhall following her accession and stopped off at Christ's Hospital to listen to a speech from the scholars. This can be seen depicted beneath the standing figure of Victoria. To the north, stands the Prince of Wales, eldest son of Queen Victoria, posing in a Field Marshal's uniform.

14. 193 Fleet Street, (1883)
Emblematic City Dragons

Sculptor: Houghton of Great Portland Street

Architects: Archer & Green

Sitting at the corner of a pawnbrokers are two dragons, with lion-like bodies, wings and grimacing faces. Representing the City Dragons, they stand either side of where the pawnbroker's golden balls hung. Only the iron support of the balls remains.

15. St-Dunstan in the West, Fleet Street, (1670-99)
Queen Elizabeth I

Sculptor unknown

This very traditional representation of Elizabeth I stands out from a pale blue niche in St Dunstan-in-the-West, having also occupied a place in the exterior of the original St Dunstan's building. Sold for £16.10s in 1830, the Church re-thought its decision, largely due to public outrage, and the statue has remained a part of the Church ever since.

16. Norwich Union Insurance, 49-50 Fleet Street, (1913)
Prudence, Justice and Liberality

Sculptor: A. Stanley Young

Architect: Jack McMullen Brooks of Howell and Brooks

These three figures were installed for the Norwich Union Insurance building, evidently intending to convey an understanding of ethics and morality to its clients, as well to inspire a sense of confidence and prosperity, as seen through the coins, fruit and flowers overflowing from Liberality's cornucopia. The firm's usual emblem of a dove and a serpent was viewed as being too open to misinterpretation to be used.

17. Queen of Scots House,
143-4 Fleet Street, (1905)

Mary Queen of Scots

Architect: R.M Roe

Mary, Queen of Scots, stands in a gothic niche, and holds a crucifix. Installed in 1905, this depiction of Mary is a generic imagining; the building was the manifestation of Sir Tollemache Sinclair's penchant for the doomed queen.

18. Daily Telegraph Building,
135-41 Fleet Street, (1929-30)

Decorative Masks of The Past and The Future, Panel depicting Two Mercuries

Sculptor: Samuel Rabinovitch, AJ Oakley (with possible contribution from S Rabinovitch)

Architects: Elcock and Sutcliffe

These two faces were designed and direct-carved for the Daily Telegraph Building. The Past, facing west, cuts a skeletal, unhappy image; while The Future looks east with a fresh, almost blank, face. Samuel Rabinovitch, who created the faces, embarked on a hiatus from life as a sculptor after the faces' completion, choosing instead a career in wrestling.

The art-deco panel by AJ Oakley displaying two figures of Mercury, patron of communication, shows each running in the opposite direction, against a backdrop of a map of Europe, in which the UK is most prominent, inside the rays of a sun.

19. 85 Fleet Street, (1938-9)
The Herald

Sculptor: William Reid Dick

This bronze female herald sits on a globe while blowing a trumpet. Initially placed on the 6th floor of the building, the figure was later moved to an oculus above the main door. Unveiled to mixed reaction, The Herald has been seen as both an international symbol of news and as woman sitting astride a Swiss exercise ball.

20. St Bartholmew House,
92 Fleet Street, (1900)

Overdoor Relief

Sculptor: Gilbert Seale

Above the door to St Bartholomew House sit two winged children, dated at 1900, one with bow and arrow; the other with flowers in his hair.

21. Pie Corner Boy,
1 Cock Lane, (late 17th century)

Sculpture on Bracket

Sculptor: Unknown

Situated on Cock Lane, the Pie Corner Boy, or The Glutton, was erected following a fire which spread from Pudding Lane to Pie Corner, believed to have been sent to teach greedy Londoners a lesson. The Glutton has, however, been noted for its less than gluttonous appearance: taking the form of a young boy, the figure is less rotund than one might expect of a figure representing greed.

22. Cripplegate Institute Building,
1 Golden Lane, 1910-11

Carved pediment of Education, Art and Science.

Architect: F. Hammond (in consultation with S.R.J Smith)

Originally forming part of the Cripplegate Institute, this pediment sculpture was added 15 years after the building's completion. The scene depicts Education, sitting between Art and Science, who watch her.

23. Institute of Chartered Accountants,
Moorgate Place, (1889-93)

Allegorical friezes, Justice and Accountants

Sculptor: W.H Thornycroft

Architect: John Belcher assisted by Beresford Pite

This frieze depicts the Arts, through personifications of Architecture, Sculpture, Painting and Music, who are depicted as relaxed female figures, casually leaning above the doorway. Another depicts the Colonies, and displays India, South Africa, Canada and Australia. The male figures were all based on real-life acquaintances of the sculptor.

Justice and Accountants was proposed by W. H. Thornycroft, and given a prominent position atop a dome. Blindfolded and holding her sword and scales, she stands in the forefront, dwarfing the accountants, who are hiding behind her. Justice is greater than accountants. The building was officially opened, to critical acclaim, in 1893.

24. Institute of Chartered Accountants, Great Swan Alley, (1890-2)

Corbel of Corner Oriel

Sculptor: Harry Bates

Architect: John Belcher assisted by Beresford Pite

These winged mermen support the corner of the building, and stand to either side of the Institute's coat of arms, on which can be seen the scales of Justice and the figure of Economy standing underneath.

25. 42-44 Gresham Street, (1850-2)

Queen's Assurance Sign

Architect: Sancton Wood

An assured bust of Queen Victoria takes centre space between two winged cherubs, who are placing a crown on her head. Laurel and oak are present to the left, while roses and thistles are placed to the right.

26. Prudential Assurance Building, Holborn, (1898)

Allegorical Figure of Prudence

Sculptor: W Birnie Rhind

Architect: Alfred Waterhouse

Unsurprisingly, above the entrance to the Prudential Assurance Building stands the robed figure of Prudence, here depicted carrying a mirror – the traditional accessory of Truth and Virtue. This figure bears a remarkable resemblance to one for the same company at 1 St Andrews Square, Edinburgh.

27. City Temple, Holborn Viaduct, (1873-74/2000)

Pediment sculpture, Winged Lion, Sir William Walworth

Sculptor: Farmer and Brinley, Henry Bursill (original)

Architect: Lockwood Mawson

On the pediment of the City Temple we see Faith, seated with a rather large cross, next to Hope and Charity. Towards the edges, assembled objects appear less logical: two tables, one with bread and fish, an oil lamp and a fire pit, as well as a star and a chair.

The Winged Lions hold globes under their left paws, a rather imperialistic expression of British domination.

The sculpture of Sir William Walworth, a 14th century Lord Mayor of London and surpressor of the Peasants' Revolt, was created by Henry Bursill in 1869. Having been destroyed, presumably during the Second World War, it was replaced in 2000 in this rather loose interpretation of the original.

28. Barclay's Bank, King Street, (1893-4)

Figure of Atlas with Globe

Sculptor: Thomas Tyrrell for Farmer Brindley

Architect: Alfred Waterhouse

Bearing the weight of the world on his shoulders, Atlas kneels on one knee over the entrance to the former Atlas Assurance Building. Criticised at the time for being too thin, and not the buff representation normally used, the figure was generally well-received.

29. Old Bank Station, King William Street, (1899)

Allegorical Figure of Electricity and Speed

Sculptor: Oliver Wheatley

Architect: Sydney Smith

Two reclining, semi-nude figures, on the front of the old Bank Station, personify electricity and speed; although neither appear in a particular hurry. Electricity, the female figure, can be seen with a spark coming from her finger, while Speed, the male, wears a winged hat and carries the caduceus.

30. Moscow Narodny Bank, 81 King William Street, (1899)

Allegorical Figures of Unity and Security, Wisdom and Foresight

Sculptor: Oliver Wheatley

Architect: W. Curtis Green

These figures demonstrate excellent posture, sitting with backs upright, looking outwards from what was once the London Life Association building. Such imagery – allusions to unity, security, wisdom and foresight – are fairly typical of such companies, to inspire confidence in the company's practices.

31. Lime Street,
near Fenchurch Avenue, (1954-7)
Allegorical Figures of the Four Elements

Sculptor: James Woodford

Architect: Terence Heysham

Part of the former Lloyd's of London building, these personifications of the four elements – Earth, Air, Water and Fire – depict both their indispensable and their threatening nature. Earth is depicted sowing seeds, with livestock at his feet; Air is a winged figure next to a bird and an aeroplane; Water is ringing the Lutine Bell (recovered from the ill-fated Lutine in 1858), which is traditionally sounded at Lloyd's when a ship sinks; and Fire shows a fireman riding on a phoenix.

32. 24-8 Lombard Street
(South Side), (1914)
Chimera with Fire and the Sea

Sculptor: F.W Doyle-Jones

Alluding to the dangers of fire and sea, these personifications, above the entrance to the building originally built as the HQ for Royal Insurance, wield props including a caduceus, a torch and faggots. Between them sits a monstrous chimerical figure with a woman's head, wings and a lion's paws, standing atop a globe. The group of figure were intended to frighten potential customers; a novel sales technique.

33. Adelaide House,
London Bridge Approach, (1921-5)
Female figure holding a globe

Sculptor: William Reid Dick

Architects: Sir John Burnet and Thomas S. Tait

This eerie and haughty female figure appears to be carved into the building: she bears the same dividing lines as the stones behind her. Almost completely symmetrical, only the crossover of her hands betrays her.

34. 7 Lothbury,
East of St Margaret Lothbury, (1866)
Relief sculpture

Sculptor: James Redfern

Architect: George Somers Clarke Snr

Originally designed for the General Credit Company in 1866, this relief sculpture usefully combines imagery of the act of giving credit (centre) with successful business enterprises, including allusions to mining, railways, engineering, spinning and sailing.

35. Lower Thames Street, (1873-8)
Figures of Britannia, Dolphins and City Arms

Architect: Horace Jones

These figures, which sit on top of the former Billingsgate Market, cost £300, and were carved by an unknown sculptor. The grandeur of the facade – which depicts Britannia, flanked by two dolphins, overseeing all who enter – reflects Billingsgate's position as the largest fish market in the world, following this new design by Horace Jones in the late-nineteenth century.

36. Mansion House,
The City of London, (1744-5)
London Trampling Envy

Sculptor: Robert Taylor

Mansion House was built in the eighteenth century for the Lord Mayor of the city. This rather violent pediment piece depicts the female figure London wielding a spear, trampling over Envy, while a woman to her right attempts pacification by offering tribute from a cornucopia, and a strangely relaxed river god reclines to her left.

37. 109 East India House,
Middlesex Street, (1992-3)
'Rebellion' Statue

Sculptor: Judy Boyt

When completed in 1993, this piece was first exhibited in Trafalgar Square, and later moved to its current position on a turret of East India House. Made of bronze, the mutinous stallion rears up, despite the reins it wears.

**38. Portsoken House,
84-5 The Minories, (1927-8)**

*Putti with a Garland; Putti with
an Armorial Cartouche*

Sculptor: P Lindsey Clark

Architect: G Val Myer

"They're just big babies." These chubby children, created in the late 1920s, show no indication of the events to come, holding a celebratory garland over the window, and a coat of arms over the door.

**39. 13-15 Moorgate,
West side of the street, (1890-3)**

Architectural Sculpture. Allegories

Sculptor: William Silver Frith

Architects: Aston Webb and Ingress Bell

Above the first floor windows we see Confidence Prudence, Justice, Truth, Thrift and Self-Denial: this bunch, resembling a 19th century girl band, stand in the niches of the Metropolitan Life Assurance building.

**40. Electra House, between Finsbury
Circus and London Wall, (1900-3)**

*Female Figures representing Egypt and Japan,
spandrels representing Electric Telegraph,
allegorical panels*

Sculptor: W Goscombe John,
George Frampton, FW. Pomeroy

Architects: Belcher and Joass

Intended as a frieze depicting the global nature of electric telegraphs, only Egypt, Japan and two other countries made it on to the final exhibit, after budget cuts rendered the initial project unviable.

Additional spandrel figures represent the communications possibilities of the electric telegraph. Seated on one side of the doorway are figures sending a telegraphic message, and on the other side, two figures receiving it. Telegraph cables run along the top as decoration. On the allegorical panels we see a female figure wearing body armour and a helmet, and brandishing a length of cable, which loops around a globe. To her right, a figure carries batteries (perhaps her personal massager has stopped working), while the figure on the left appears to be an oriental woman; suggestive of the exoticism of long-distance communication.

41. 1 Poultry, (1936-7)

Statue depicting Boy with Goose

Sculptor: Wiliam Reid Dick

Architect: Edwin Lutyens

The theme of poultry is taken from the junction on which the building is located: that of Poultry with Old Jewry. Here, we see a boy playing (rather roughly) with a goose; the two playmates are equals in size.

**42. National Westminister Bank,
1 Prince's Street, (1931)**

Figures depicting Security and Prosperity

Sculptor: Charles Doman

Architect: Sir Edwin Cooper

Two allegorical figures display the attributes customers expect of their bank: Security and Prosperity. Security holds keys and chains, while Prosperity bears exotic fruits.

**43. Thames House, Queen Street Place
(West Side), (1911-12)**

Pediment of North Pavilion

Sculptor: Richard Garbe (attr.)

Architect: Stanley Hamp

This building was the Liebig Extract of Meat Company HQ, and its completion also marked the launch of the Oxo Cube. This pediment sculpture displays the horse, Pegasus, who appears to be, rather sensibly, desperate to leave the building, being restrained by naked figures.

44. Vintry House, Queen Street, (1927-8)

Tympanum Relief

Sculptor: HW Palliser

Architects: Kersey, Gale and Spooner

Above the entrance stands a nude woman, holding bunches of grapes, which grow down vines beside her. She is flanked by two goats who gaze up at her in awe, and four doves above her head. She looks rather pleased with her bounty.

**45. The Black Friar Public House,
174 Queen Victoria Street, (1917-21)**

Keystone depicting a singing friar

Sculptors: EJ and AT Bradford

In the Small Saloon Bar in the pub, we find keystones depicting scenes from nursery rhymes. The pub underwent a twenty-year renovation in the early twentieth century, during which sculptures, mottoes, keystones and even entire rooms, were installed.

46. The Royal Exchange, (1842-4)

Pediment sculpture

Sculptor: Richard Westmacott, Jnr

Underneath Commerce is an inscription bearing the words: 'The Earth is the Lord's and the Fulness Thereof'. This, perhaps, a reminder of the lack of human authority over the world – fitting, for a building which had now been rebuilt three times, having first burned down in the Great Fire of London, and then again in a later fire.

47. St Andrew Holborn, (After 1721)

Charity Boy and Girl Sculptures

These blue-uniformed figures are present in locations across the city, and mark charity schools (blue being the cheapest dye available). Following the bombing of St Andrew's Parochial School, the Charity Boy and Girl were moved to the church.

48. St Bartholomew's Hospital, Facing West Smithfield Gatehouse, (1702-3)

Figures depicting Lameness and Disease

Sculptor: possibly Edward Strong Jnr

An uplifting sight for any patient arriving at St Bartholomew's Hospital: Lameness and Disease look down upon those who enter, against a backdrop of decorative crutches and fruit. One wonders if these days, Lameness would be represented by and ITV sit-com.

49. Nomura House, St Martin's Le Grand and King Edward Street, (1889-95)

Postmaster General Keystones, spandrels

Architect: Sir Henry Tanner

This building was originally built as the part of the General Post Office; the keystones bear portraits of Postmasters General. Spandrels present a fitting image for the General Post Office: an older man to the left writes a letter, while the man on the right reads a scroll. The figures are more informally dressed than you would expect to find in a Post Office today.

50. Watermen's Hall, St Mary at Hill (West Side), (1779)

Company Arms, Triton Reliefs and River God Keystone

Architect: William Blackburn

Watermen transport passengers along, and across, rivers; these decorative sculptures, including oars, dolphins and a sea-god, can be found on the side of the Watermen's Hall.

51. St Paul's Cathedral, (1706)

The Conversion of St Paul

Sculptor: Francis Bird

The pediment sculpture of St Paul's Cathedral depicts the conversion of St Paul: radiant light shines down upon Saul, whose horse has fallen and whose helmet has fallen off.

52. St Paul's Cathedral (North Pediment), (1698)

Angels with the Royal Arms

Sculptor: Grinling Gibbons

Two angels carry the royal coat of arms, as a part of the north pediment decoration.

53. St Paul's Cathedral (South Pediment), (1699)

Phoenix relief

Sculptor: Caius Gabriel Cibber

The phoenix rises from flames; a symbol of the rebirth of London following the Great Fire. Underneath it is the inscription: RESURGAM. This had initially been intended for one of the Great Fire Monuments, but it was instead used for the south pediment of St Paul's.

54. Smithfield Market, facing Charterhouse Street and West Smithfield, (1868)

Statues depicting Dublin, Liverpool, London, Edinburgh

Sculptor: C.S Kelsey

These figures were produced to mark the north and south entrances to the Meat and Poultry Market. Edinburgh is identified through its flag and thistles; London has a sword and a caduceus; Dublin carries a Celtic cross; and Liverpool holds the rudder of a ship.

55. The Temple, Fleet Street, (1683-4)

Lamb and Flag Keystone

Architect: Roger North

The lamb and flag is an emblem believed to have been used by the Templars; this example is situated on the gateway to Middle Temple on Fleet Street.

56. The Temple, Tudor Street, (1887)

Pegasus Relief

Sculptors: J. Daymond & Son

Architect: Arthur Cates

The emblem of Pegasus is also thought to be linked to the Templars; this one can be found on the gateway to the Inner Temple, on Tudor Street.

57. Temple Gardens (South Front), (1878-9)

Queen Victoria and Merchildren Keystone

Sculptor: Mabey & Co

Architect: E.M Barry

Overlooking the Thames, this keystone is a portrait of Queen Victoria, surrounded by winged merchildren and laurel.

58. Temple Chambers, Temple Avenue, (1887)

Atlantean figures on either side of doorway

Architect: John Whichcord

Either side of the doorway to the Temple Chambers is a male figure: one a king or sorcerer, wearing a crown, and one a captive, gazing into the distance. Each supports the structure above on his shoulders and sports a beard any hipster would be proud of.

59. Bank of Scotland, 37-8 Threadneedle Street, (1803)

Relief with two Sailors

Sculptor: John Bacon, Jnr
(and a later restorer)

Originally the British Linen Bank, this building replaced the former South Sea Company's much older offices. Over the door we can see two sailors, leaning against a globe. A more recent restoration project replaced the figures' heads; both now appear to be in the early stages of growing mullets. The Neptune door guardian beneath has a magnificent walrus moustache.

60. Draper's Hall, Throgmorton Street (North Side), (1898-9)

Persian Atlantean figures

Sculptor: Henry Pegram

Architect: Thomas Graham Jackson

Two Persian men hold their turbans (and also the entire doorway structure), yet they remain surprisingly under-dressed considering their presence at the entrance to the Drapers' Hall.

61. Former Port of London Authority Building, Trinity Square (North West), (1912-22)

Father Thames, Exportation and Produce, Commerce and Navigation

Sculptors: Albert Hodge and Charles Doman

Architect: Edwin Cooper

Loud and proud, Father Thames appears on the front of the tower, naked but for a cape, and pointing towards the docks. Personifications of Exportation, Produce, Commerce and Navigation appear on each side of the tower.

62. Victoria Embankment, (1870)

Lamp standard with dolphins

Designer: G. Vulliamy

These lamp pedestals can be found along the Embankment; their decorative additions to the river wall include river gods, the coat of arms of London, and two dolphins, twisting around the lamppost. Sixteen can be found along the Embankment between the City boundary and Blackfriars.

63. Victoria Embankment, (1875)

Laden Camel Seats

Modelled by Z.D. Berry & Son

Modelled on a silver snuff-box in the shape of a seated camel, these seats were paid for by the Grocer's Company (which possibly also had in its sights a lease on some of the land near the Embankment; the Company, however, were unsuccessful in their bid a few years later). The benches date to 1875, when their creator, Z. D. Berry was paid £270 on their completion.

64. Victoria Embankment, (1847-9)

Dragon Boundary Mark

Designer: J.B. Bunning

Dragons can be found on both sides of the road at the City boundary. They were originally a part of the Coal Exchange, but after the building was demolished in the 1960s they were kept as boundary markers; the model was then used city-wide at every main entrance to the City.

65. City of London School, between John Carpenter Street and Unilever House, (1881-2)

Francis Bacon, Drawing, Music and William Shakespeare Portrait Statues, Door guardian

Sculptor: J. Daymond & Son

Architects: Davis and Emanuel

Originally City of London School, the building displays five standing figures: Thomas Moore, Francis Bacon, Shakespeare, Milton and Newton. Here, we can see Shakespeare and Francis Bacon, between whom sit Drawing and Music, on the Victoria Embankment front of the building.

66. Cutler's Hall, Warwick Lane, (1887)

Frieze

Sculptor: Benjamin Creswick

Architect: T. Taylor Smith

This frieze, found on the front of the Cutlers' Hall, for those in the cutlery trade, shows the different stages of cutlers' work. The sculptor, Benjamin Creswick, had been a cutler himself until overtaken by ill health, and the profession is depicted in great detail.

67. St Paul's House, Warick Lane Entrance, (1963)

Chess Piece Frieze

Sculptor: Alan Collins

Architect: Victor Heal

Look carefully, and you can see different chess pieces, including the knight, the pawn and the rook, set upon a chess board on the side of this building.

68. 12-13 Widegate Street, (1926)

Reliefs of Bakers

Sculptor: P. Lindsey Clark

Architect: G. Val Meyer

This building is the former Nordheim Model Bakery. The four panels show the process of making bread, from carrying a sack of flour, to kneading dough, putting the dough in the oven and carrying the loaves out to the shop.

69. Bronze Phoenix, King William Street, (1930s)

Architect: H.L. Anderson

This grand phoenix made of bronze was created as the emblem of an insurance company, symbolising rebirth after flood, theft or fire.

LOOK UP LONDON
OUTER SOUTH AND WEST LONDON

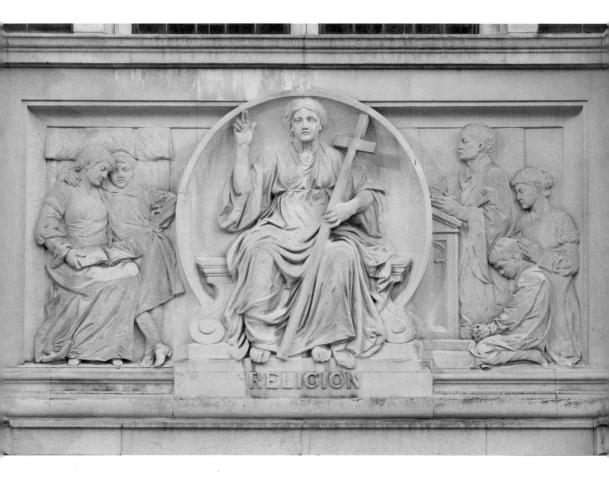

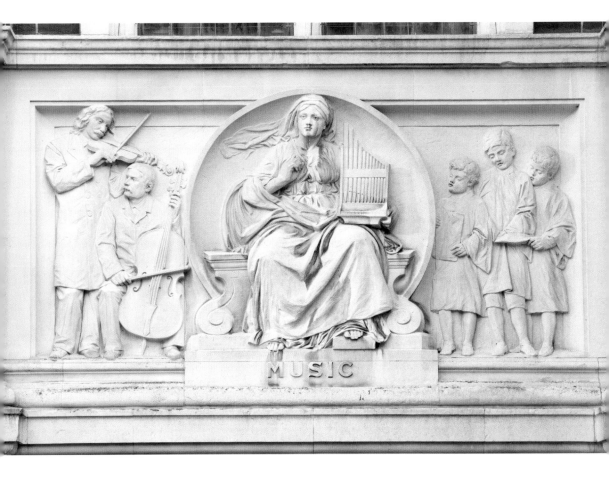

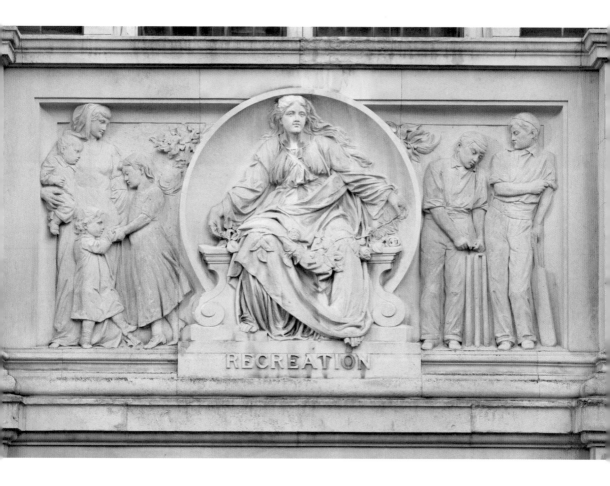

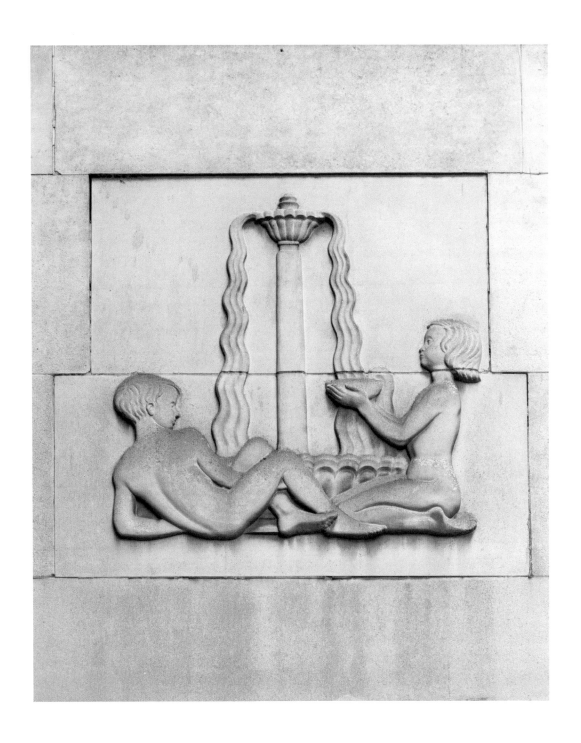

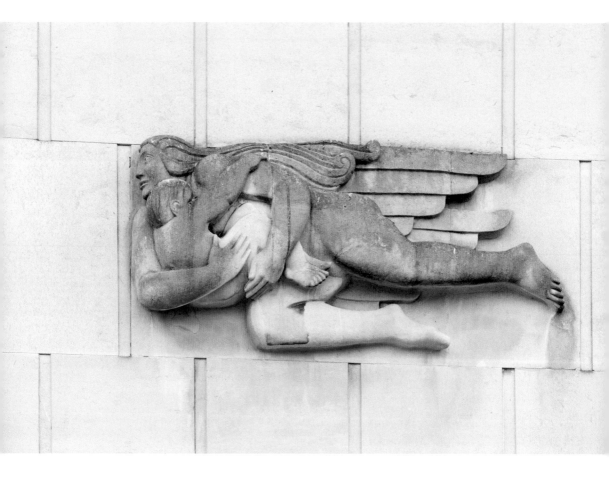

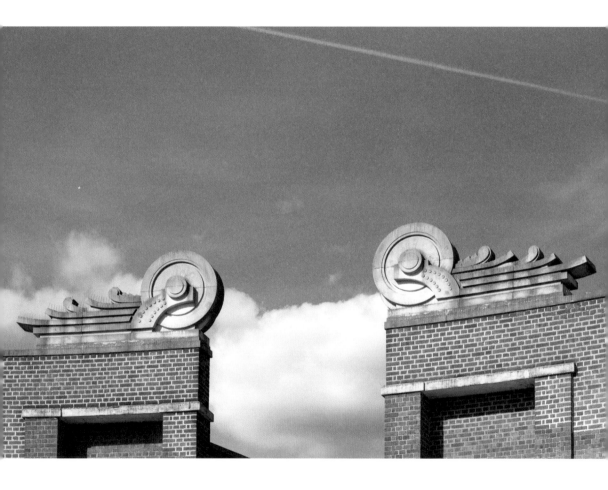

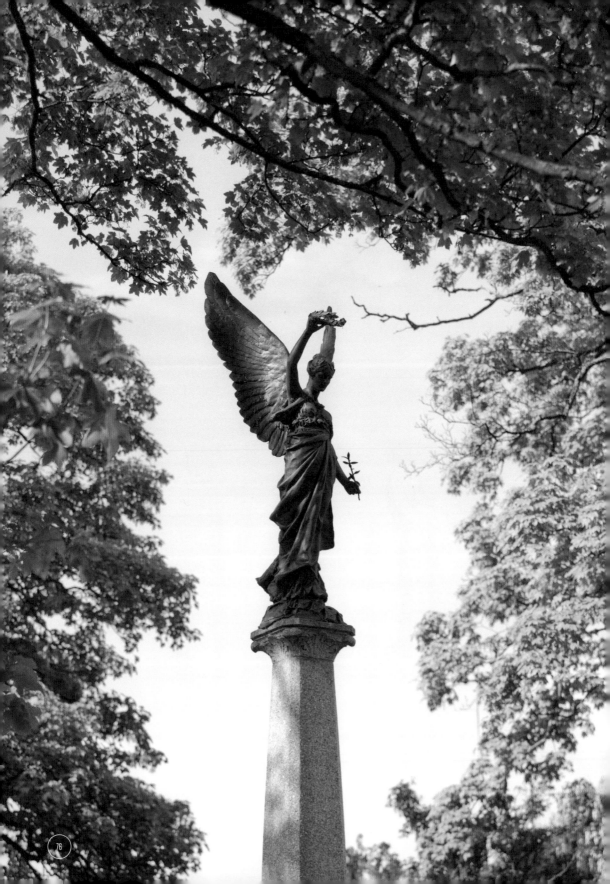

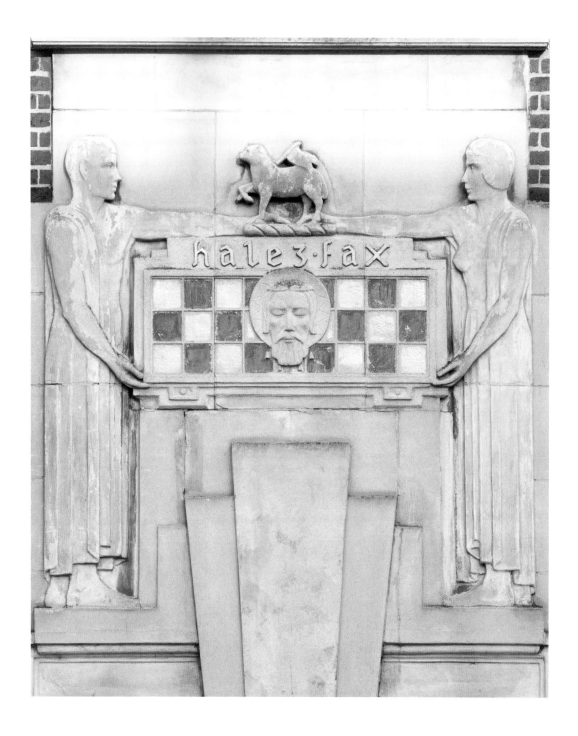

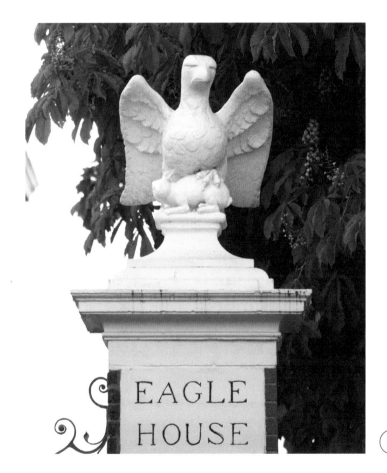

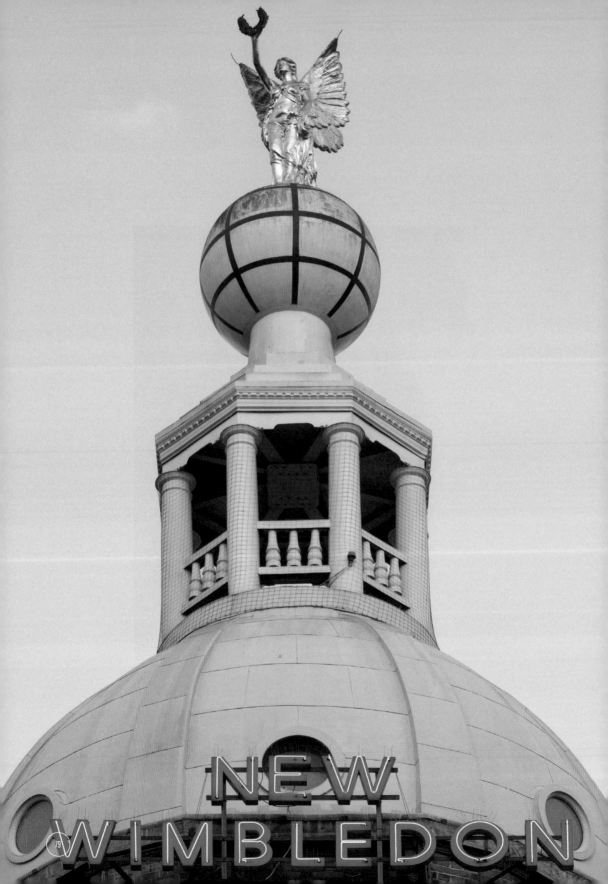

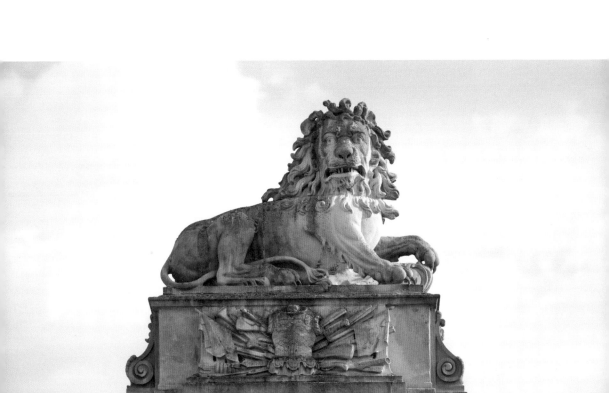

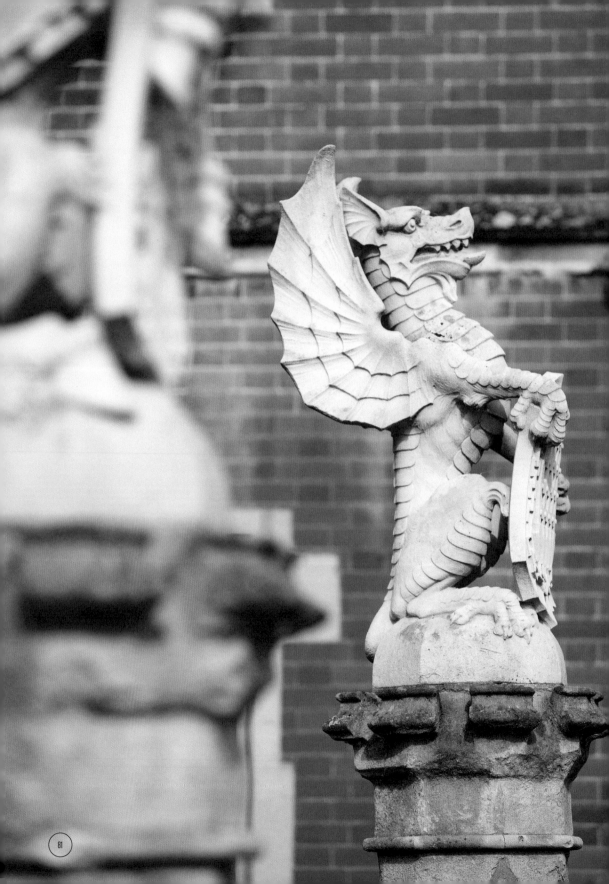

The Walls

Clare Pollard

The guiltless crowd these blackening walls, exposed
and stoical. Unwitting guards of the insiders, they
are just where they are wanted: stuck, storm-blasted,
posed for photo-ops with haloes made of pigeon-
muck. Knights made holy walls run blood but a lamb
bleats on their temple. Beneath a unicorn, a king.
Bankers bet against us, take bonuses and bailouts
but outside a mum protects her infant. Halifax is
Halezfax is 'holy face' and there is Christ's lending
legitimacy. Behind the Indian man, his sack of
water, the Anglo-Persian Oil Company count out
sacks of gold. Behind an African dancer, diamonds
trade. In my experience the innocents are there to
draw the sigh - they have no sin but, cast as stone,
look like a lasting burden; they never get to turn
to flesh, step down, be led inside by a warm hand.

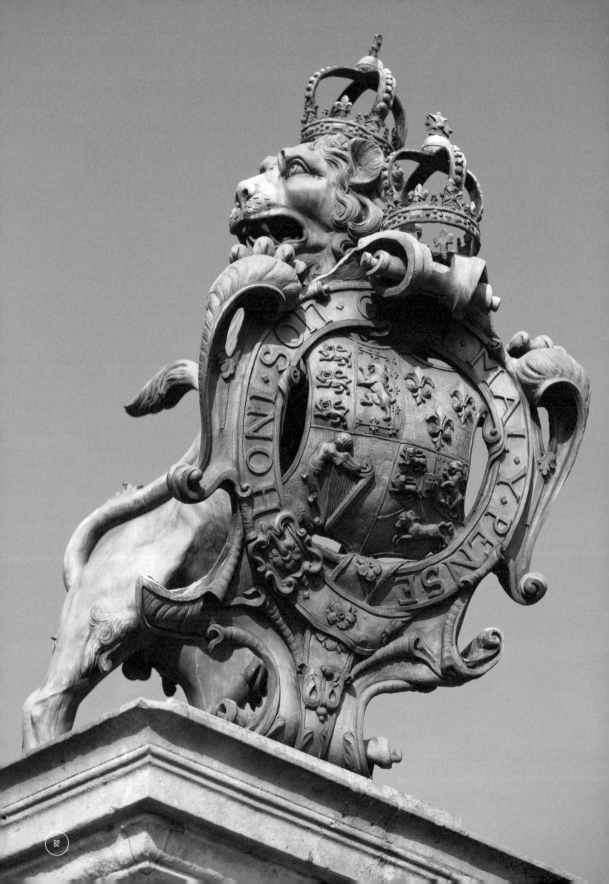

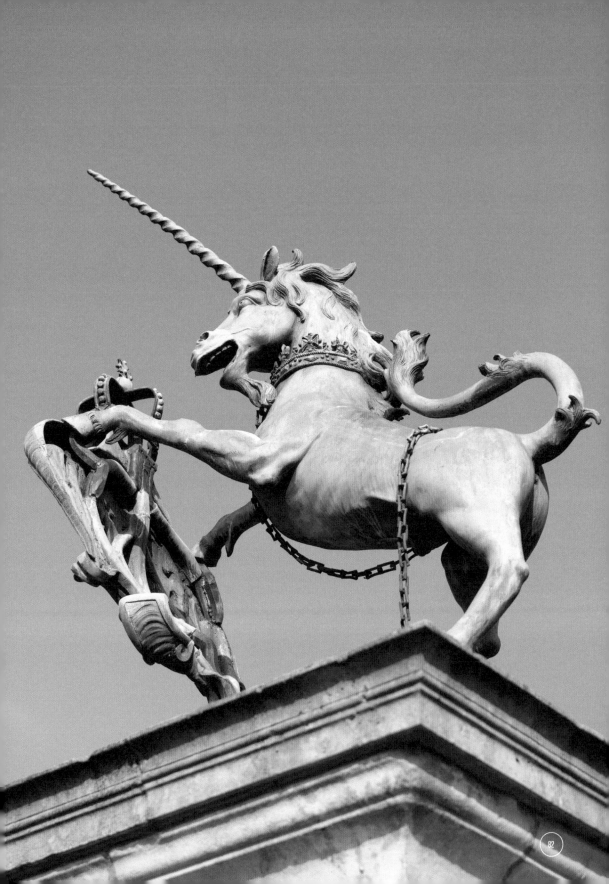

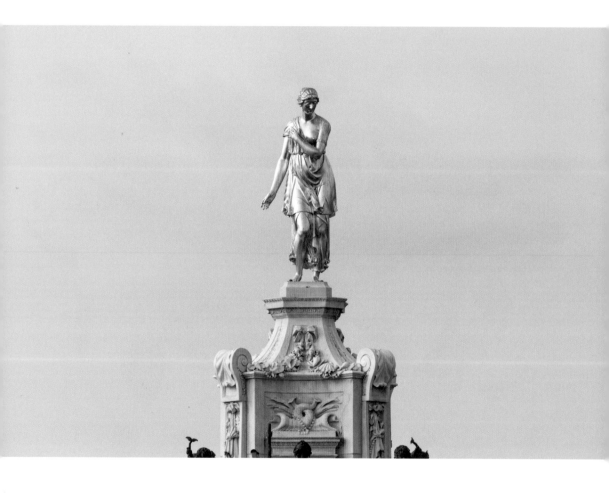

REFERENCE

70. Croydon Central Library, (1896)
Relief Panels

Sculptor: Edwin Roscoe Mullins

Five panels above the entrance to Croydon Central Library feature the allegorical figures Health, Religion, Study, Music and Recreation, to symbolise the benefits of a life devoted to physical and mental development. The panels were intended to honour the philanthropical work of John Masterman Braithwaite, one-time Vicar of Croydon, who established the public library.

71. Purley Library,
Banstead Road, (c1936)
Children at the Fountain of Knowledge Relief

Sculptor: Unknown

Architects: Gold and Aldridge

Above another library entrance we find this allegorical relief, in a very different style: children collecting water at a fountain, representing the Fountain of Knowledge. This imagery of gathering knowledge is widespread across such buildings.

72. 72 High Street,
Thornton Heath, (1954)
Winged Figure

Sculptor: Anthony Fraser

Architect: EH Banks

An angel-like figure flies across the side of the building, carrying a child to safety. This unusual figure, carved directly into the stone wall, represents both strength and care; two ideals not lost upon post-War Britain.

73. St Joseph's College Chapel,
395 Beulah Hill Road, (c1928)
St John Baptiste de la Salle
Pediment Sculpture

Sculptor: Unknown

Architect: Bernard McAdam

St John Baptiste de la Salle stands with two children at the end of the church, surrounded by drapery consisting of fruit. The dates 1651-1719, which feature on the keystone, refer to the life of priest and educational reformer Jean Baptiste Abbé de la Salle, who was canonised in 1900 for his work for the poor.

74. East Acton Lane
Corner of Green Close, (1931)
Fortitude Sculpture

Sculptor: Phoebe Stabler

Architect: Charles Holloway James

This art deco figure sits in the clouds, above the entrance to a former Young Women's Christian Association (YWCA), calmly surveying all below. Its clean lines and representation of bravery was clearly intended to inspire those attending courses in the building below.

75. Uxbridge Underground Station,
Uxbridge High Street, (1938)
Winged Wheels

Sculptor: Joseph Armitage

Architects: Adams, Holden & Pearson

Above Uxbridge Underground Station, these winged wheels represent the wheels of the trains circulating below – if not the speed. This ornamentation was a part of the initial designs for the new station, which opened in 1938.

76. The Old Graveyard, Windsor Street,
Uxbridge, (1924 re-sited early 1970s)
Peace Memorial

Sculptor: Adrian Jones

This bronze figure is an angel of peace, created to memorialise Uxbridge's War-dead: holding the laurel and an olive branch, she stands amongst the debris of war. The sculptor wanted the memorial to consider peace, rather than revive the war spirit. Originally located at the RAF camp, it was moved to this graveyard in the 1970s.

**77. Halifax Building Society Façade,
86-88 Eden Street, (1935)**
Figure reliefs

Sculptor: Unknown

Architect: Gale, Heath & Sneath

Out of all the didactic and religious sculptures linked to banking, Halifax have probably gone the furthest: this neo-classical ornamentation depicts the head of Christ within a halo with the word 'Halezfax' (probably 'Holy Face', from which the word Halifax possibly comes) written above.

**78. Eagle House School,
London Road, (Early 18th Century)**
Two eagles

Sculptor: Unknown

These eagles guard the entrance to the appropriately named Eagle House, an early eighteenth century building which was built by a physician and later leased to a South Sea Company director.

79. Wimbledon Theatre, Broadway, (1992)
Wimbledon Theatre Angel

Sculptor: Unknown

At the top of the dome is a fibreglass angel, standing atop a globe, holding a laurel wreath. This figure is a modern replacement of another winged angel, the 'goddess of gaiety,' which was taken down in the 1940s following concern that it was a useful geographical feature for German aeroplanes.

**80. North Gateway,
Hampton Court Palace, (1713)**
Lion Gate Piers and Sculptures

Designer: Sir Christopher Wren (attr.)

Sculptor: Unknown

At the north gateway of Hampton Court Palace lounge a pair of lions, high upon an ornate pillared gateway. To the front are ornamental flowers and a panel depicting a variety of weapons. The lions possibly refer to the Labours of Hercules, a motif which can be seen throughout the sculptures of the palace.

**81. West Front,
Hampton Court Palace, (1950)**
King's and Queen's Beasts

Designer: EE Dorling

Symbolising the royal houses of England, these animals take the form of lions, dragons, a dog, a unicorn, a bull and a yale (an antelope-like mythical creature). The originals, dating to the sixteenth century, and ordered by Henry VIII to commemorate his marriage to Jane Seymour, were replaced in 1950.

**82. West Front Entrance,
Hampton Court Palace, (1701)**
Trophy Gates

Sculptor: Grinling Gibbons

A lion wearing a crown and a unicorn in chains, both bronze, stand above the inner gates, holding the Hanoverian coat of arms between their paws/hooves. The lion and the unicorn are, of course, symbols for England and Scotland respectively.

**83. Bushy Park Lake, end of
Chestnut Avenue, Teddington, (1714)**
Arethusa and Fountain

Sculptor: Hubert Le Sueur

Arethusa was a nymph who was pursued by a Greek God and rescued by the Greek Goddess Diana, who transformed her into a stream. Here, Arethusa stands at the top of the fountain, which features four mermaids riding on sea creatures while squeezing water from their breasts onto the giant scallop shells below.

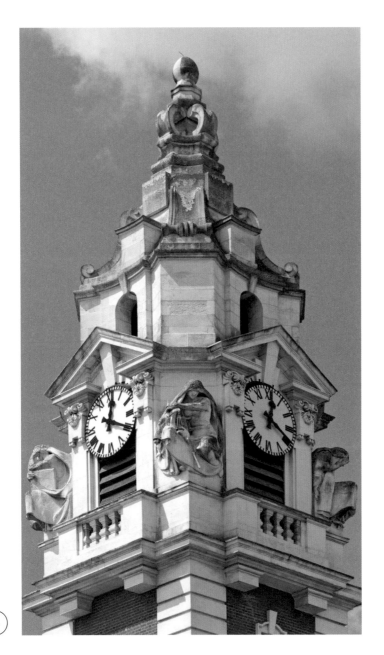

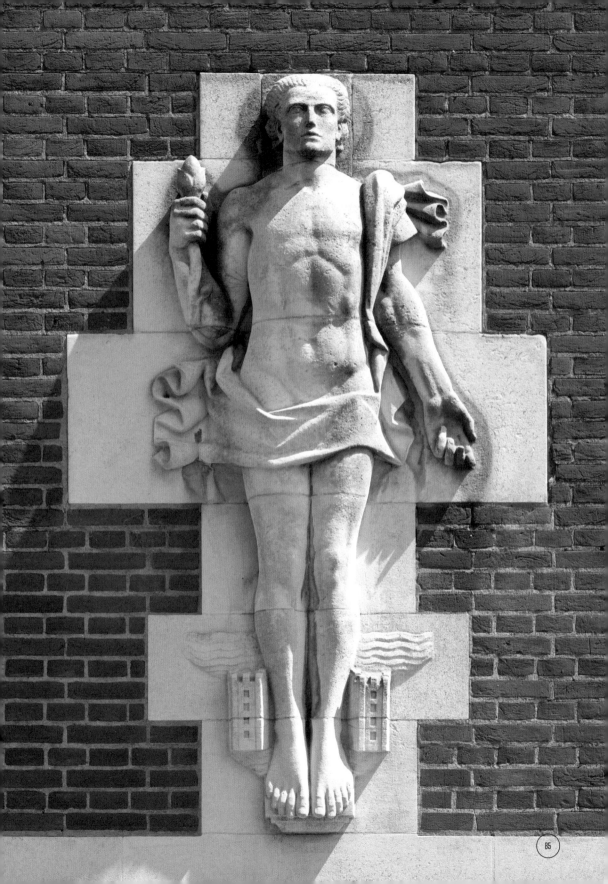

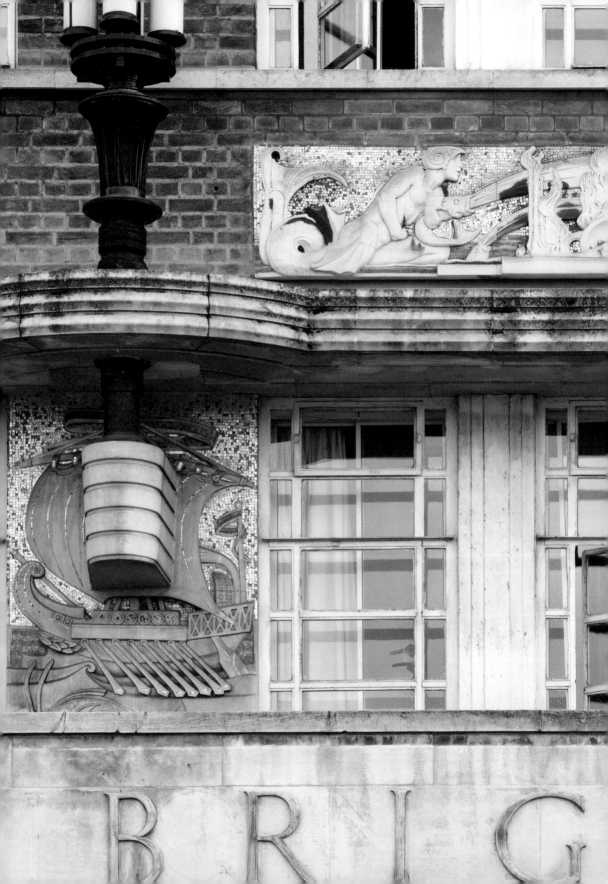

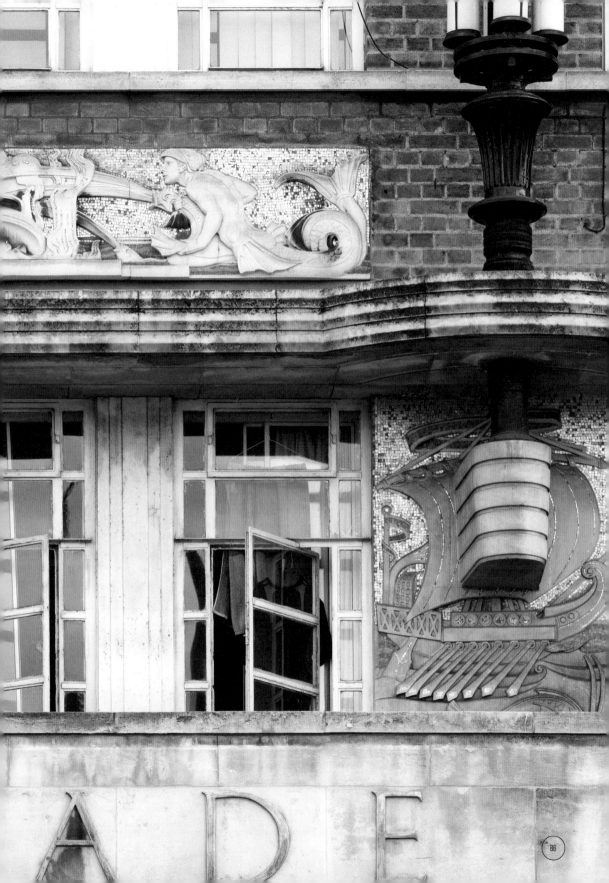

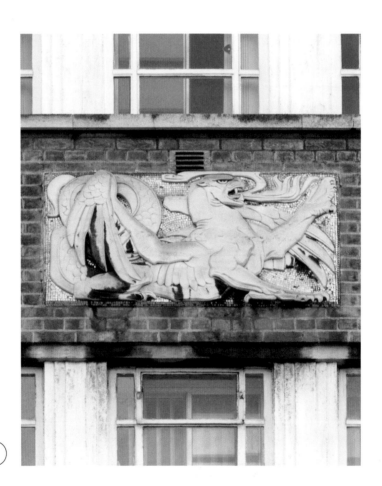

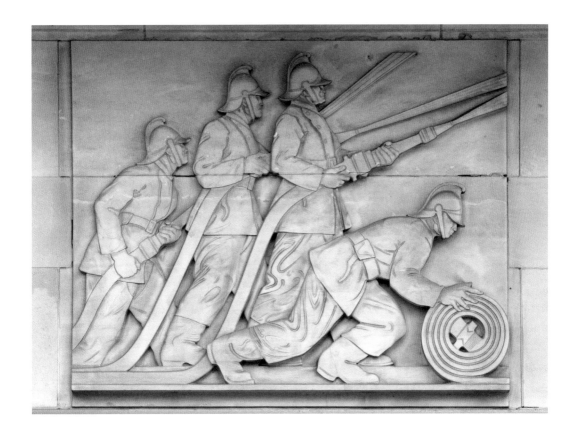

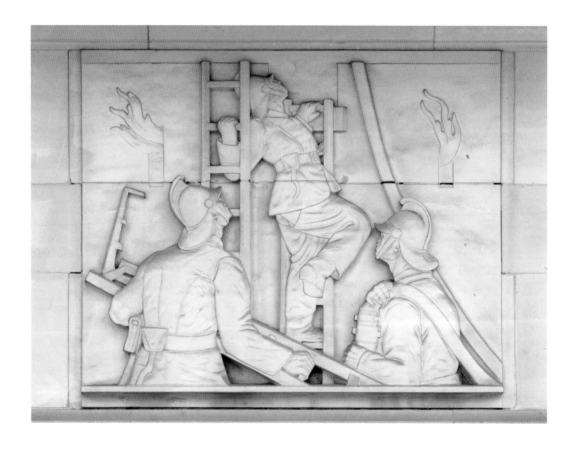

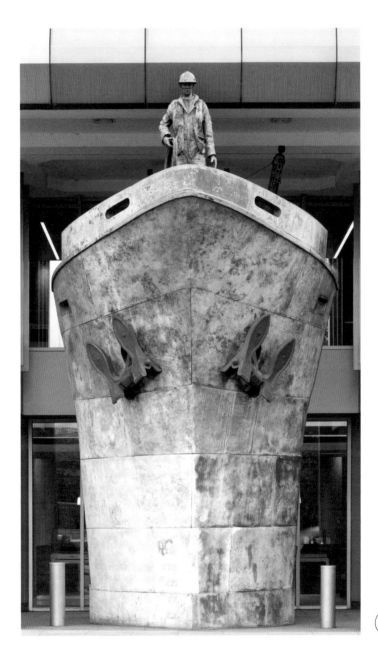

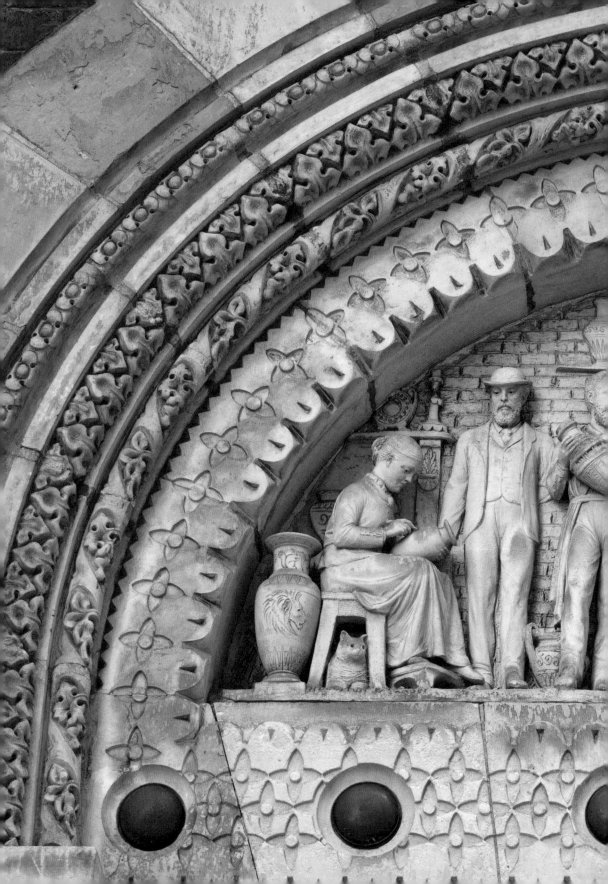

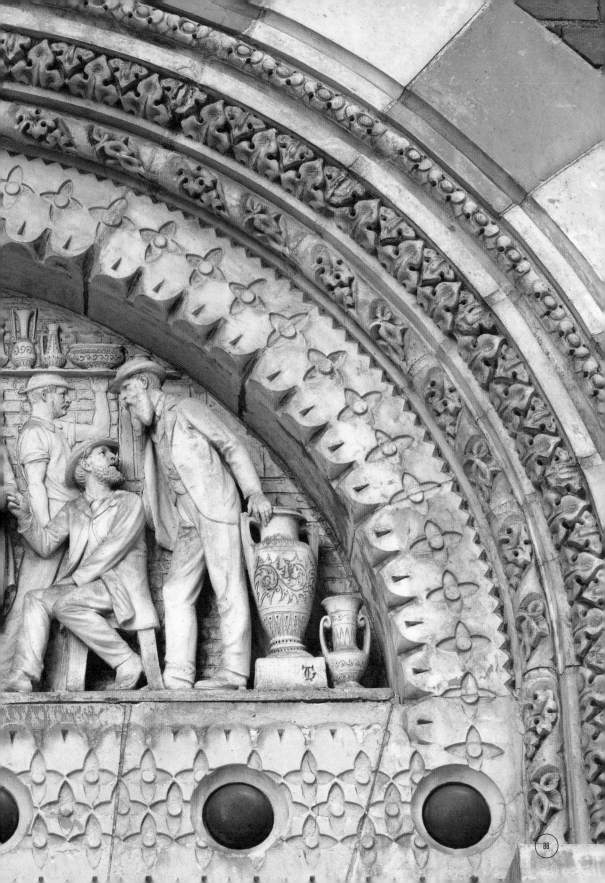

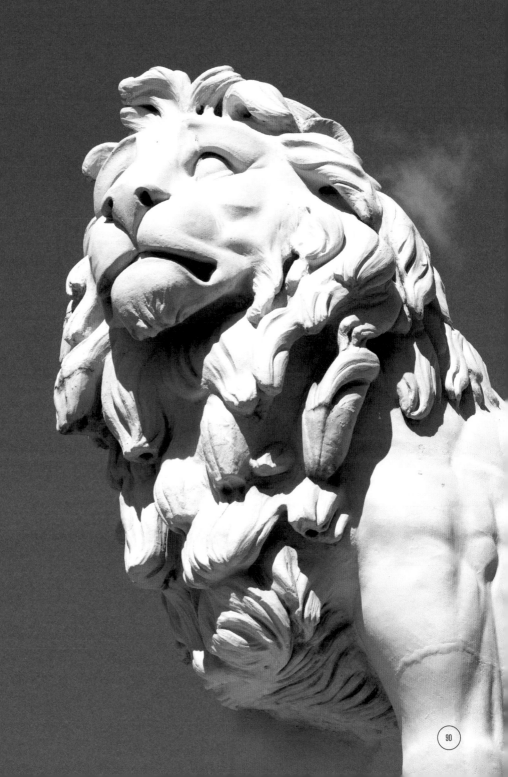

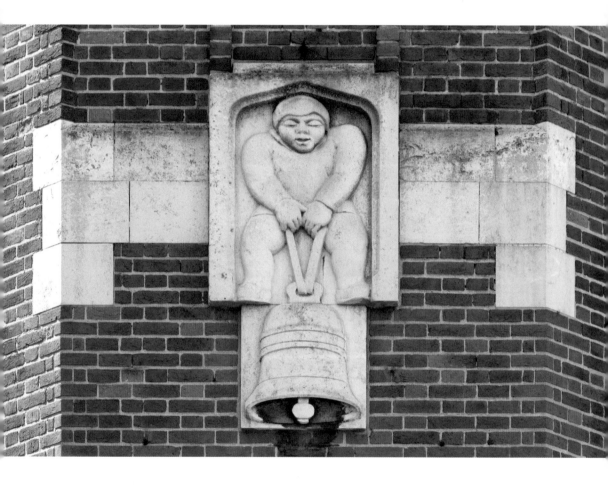

The Lambeth Crawl

Clare Pollard

let's get you an ale
says the barmaid in The Angel

in the snug there's a fire
says the barmaid at the Dagmar

fancy a nice chop
says the barmaid in The Hope

poor you there there
says the barmaid at The Lamb and Hare

my you're a one
says the barmaid at The Swan

when will you pay us
says the barmaid in The Butchers

was that a joke
says the barmaid in The Artichoke

where are your hands
says the barmaid at The Horns

you're beyond belief
says the barmaid in The Wheatsheaf

time to drink up
says the barmaid in The Roebuck

you'll burn in hell
says the barmaid in The Bell

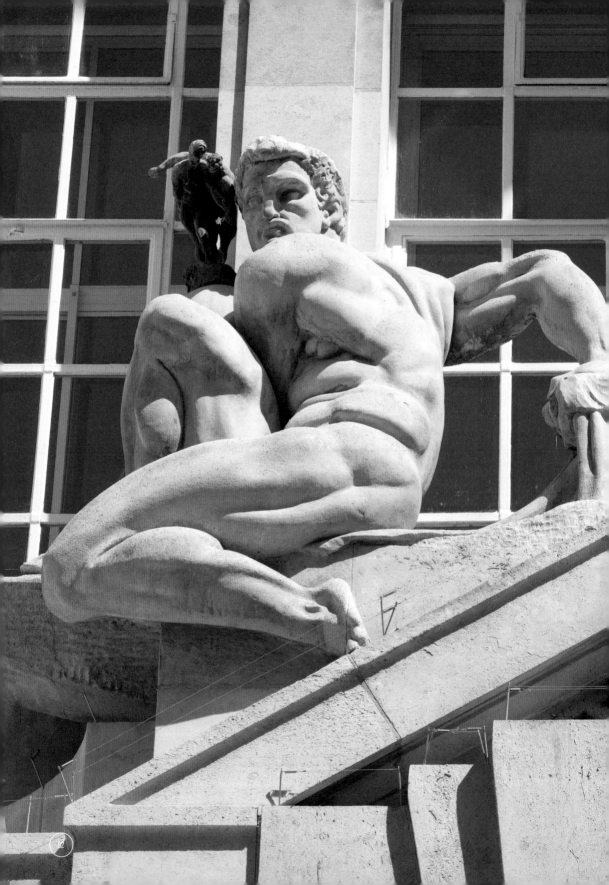

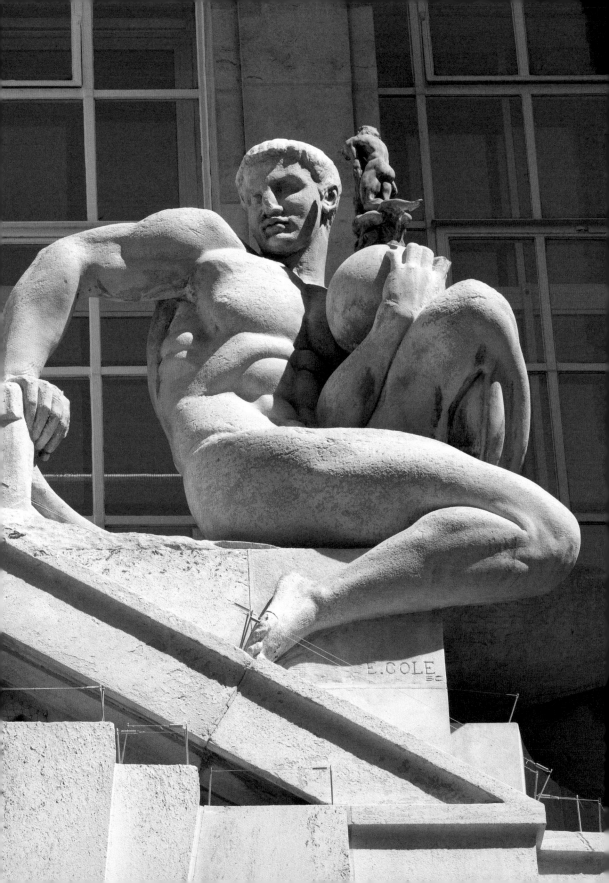

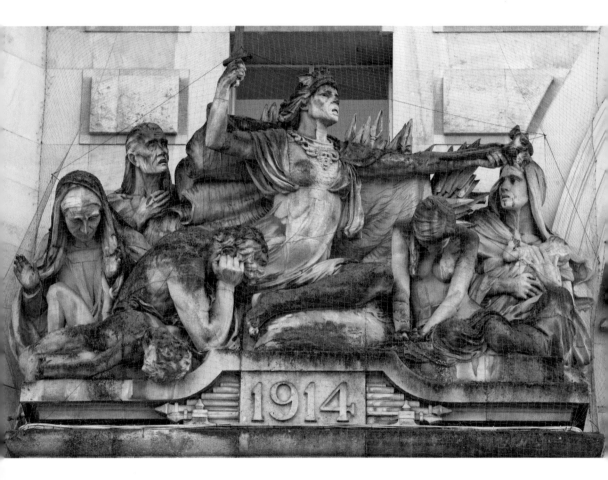

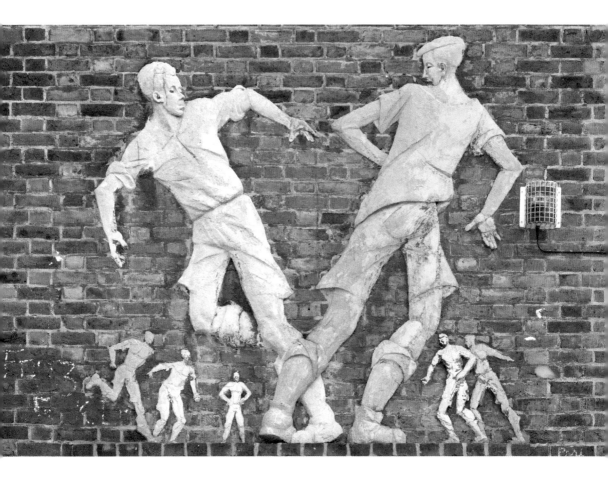

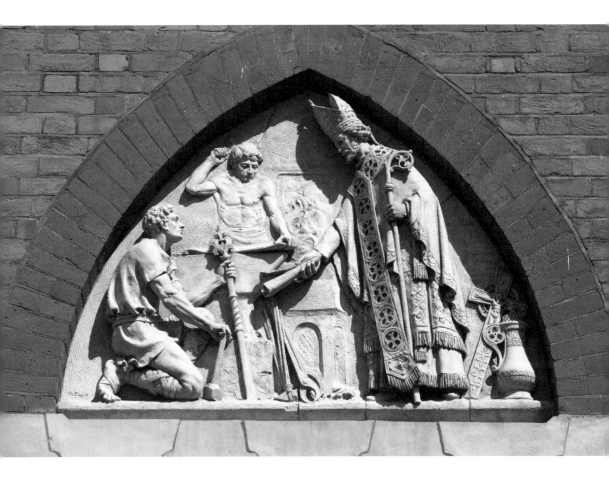

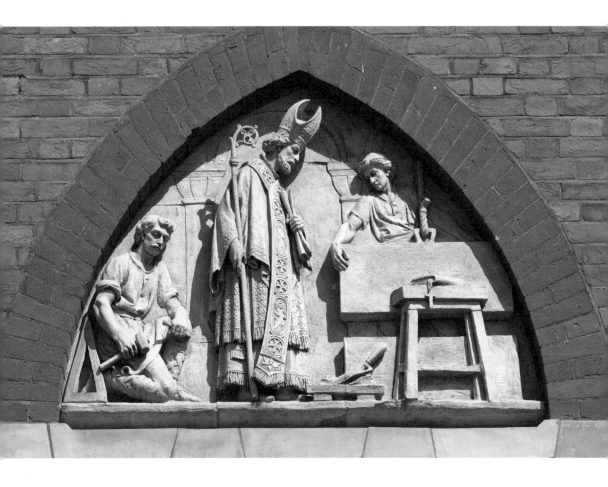

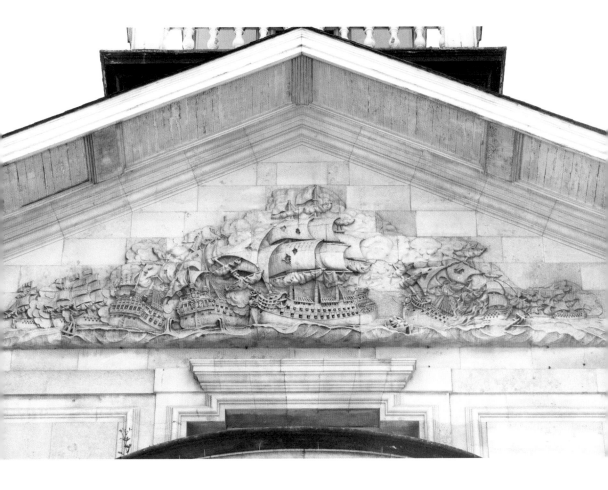

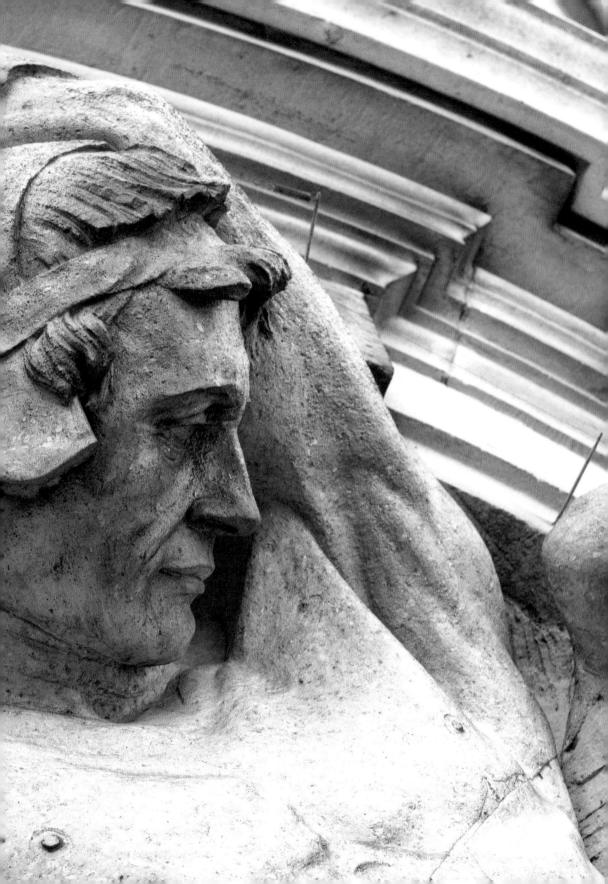

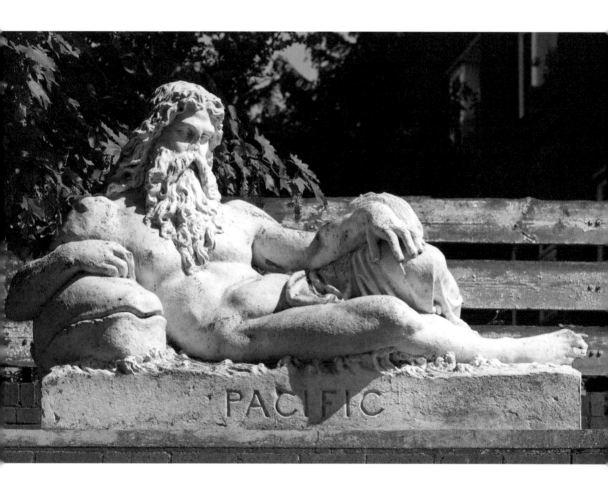

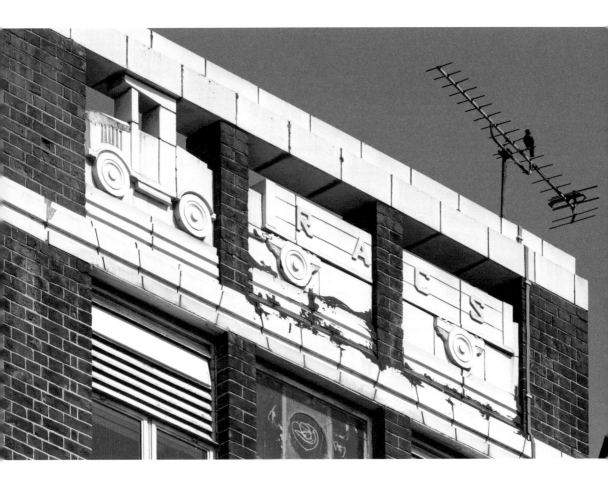

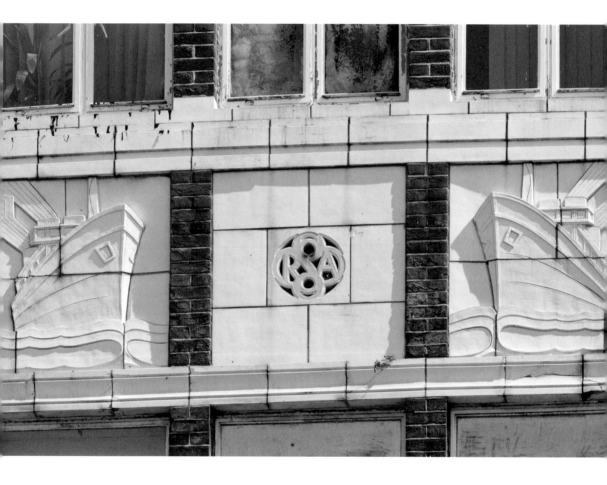

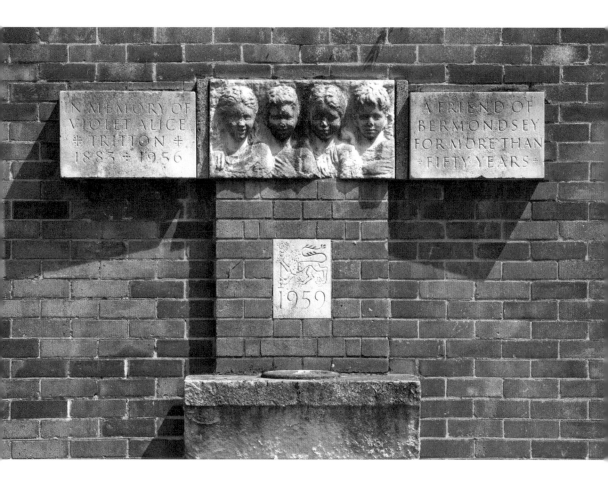

IN MEMORY OF
VIOLET ALICE
✠ TRITTON ✠
1883 ✠ 1956

1959

A FRIEND OF
BERMONDSEY
FOR MORE THAN
✠ FIFTY YEARS ✠

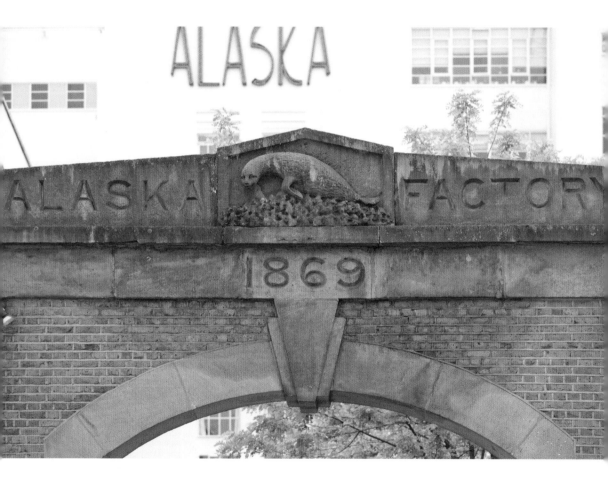

The Seal

Clare Pollard

After William Blake

> Little seal who stole thee?
> Dost thou know who sold thee?

Snatched you from the glaciers -
brought you to this furriers?
Cut your clothing of delight,
silken blubber, skin so tight;
shaved and fleshed you, watched you dye,
advertised a coat to buy?

> Little Seal who stole thee?
> Dost thou know who sold thee?

> Little seal I'll tell thee
> how I came to wear thee:

C.W. Martin & Sons
took you from the bright ocean:
freighted you to Bermondsey
to this killing factory.
Our God's not the God of seals.
You're our things. You're not as real.

> Little seal we'll use thee.
> Little seal you're money.

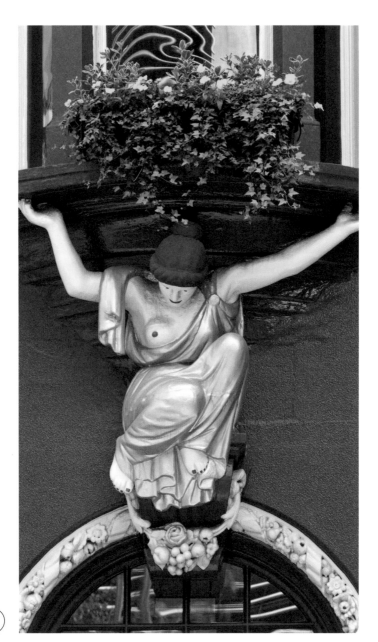

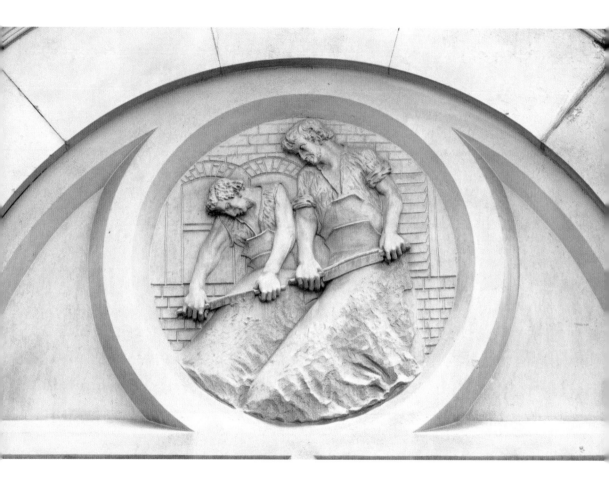

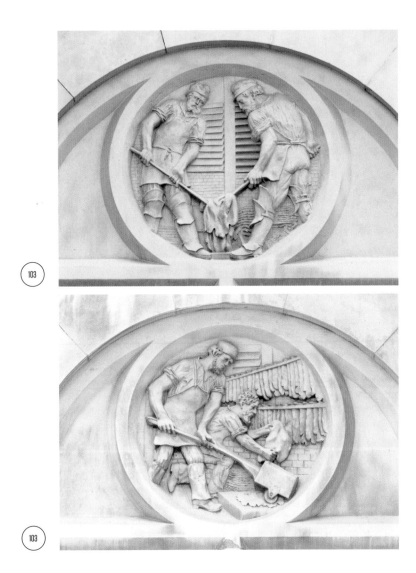

103

103

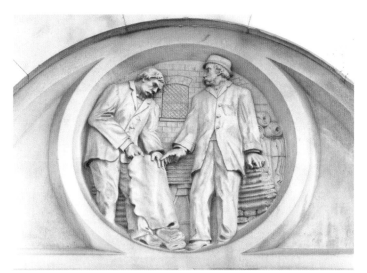

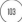

103

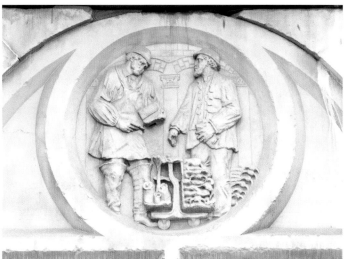

103

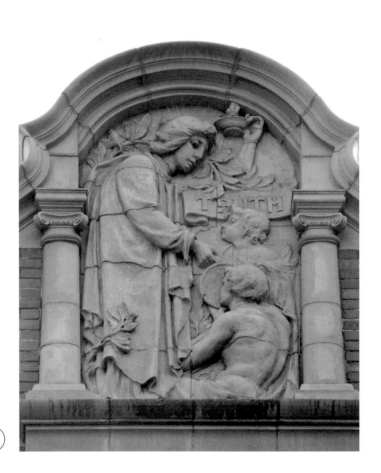

PARISH OF St GEORGE
THE MARTYR · SOUTHWARK ·

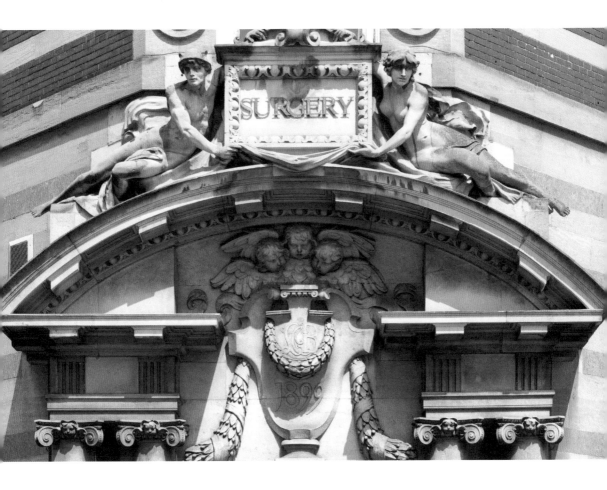

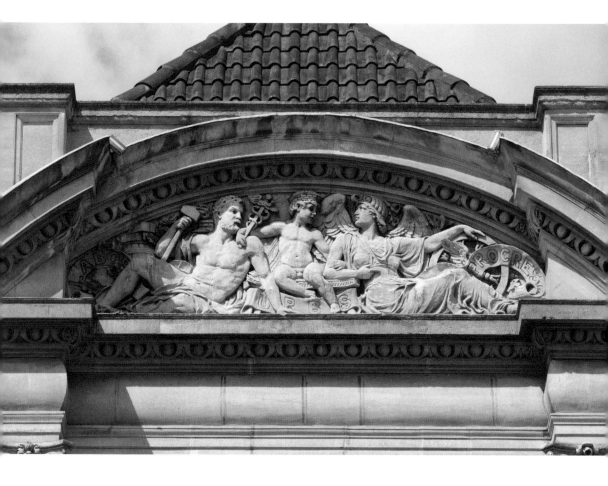

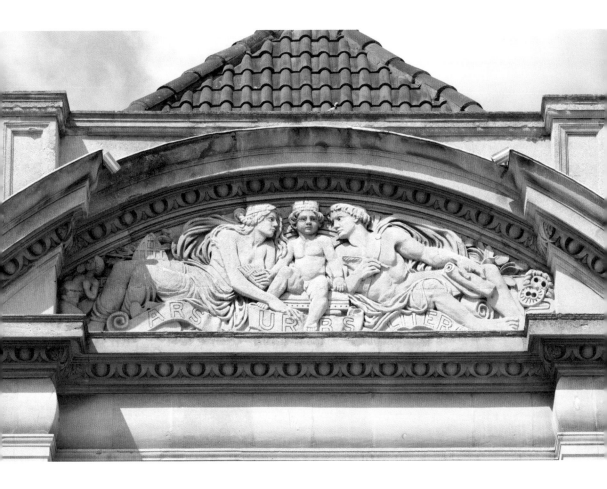

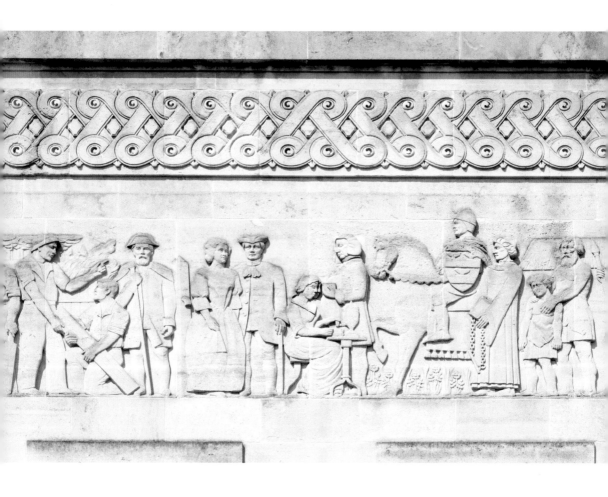

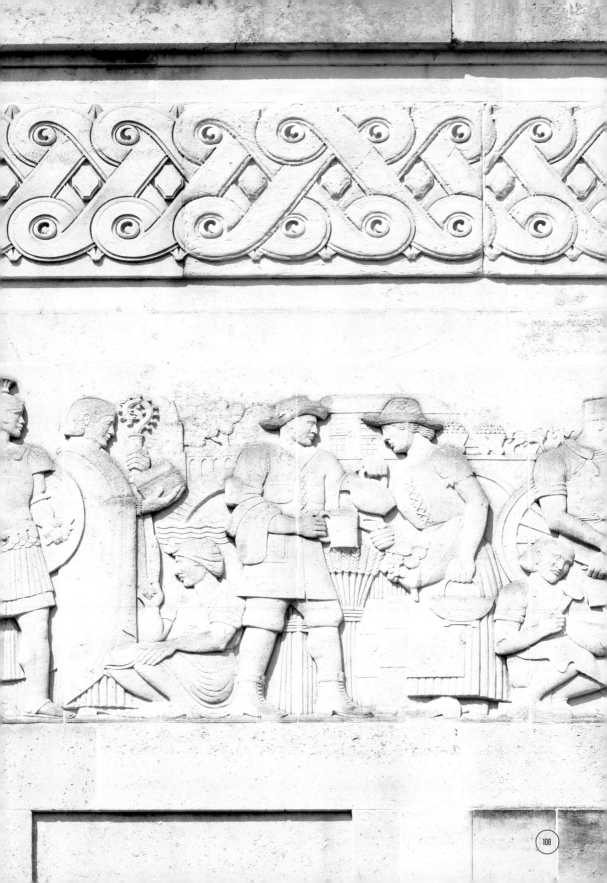

REFERENCE

84. Lambeth Town Hall, (1905-08)

Allegorical figures representing Justice, Science, Art and Literature

Sculptors: HH Martyn Co Ltd

Architects: Septimus Warwick and Herbert Austen

The clock tower of Lambeth Town Hall is decorated with four allegorical figures. They are: Justice, a female figure holding a sword and scales; Science, who is holding a retort and a pair of dividers; Art, who is missing her right hand; and Literature, the only male figure, who has a pen and book. The figures are barely visible from the ground.

85. The Assembly Hall, Buckner Road, Brixton, (1938)

Youth Rising from the Past. Sculpture in High relief.

Sculptor: Denis Dunlop

Architect: H Austen Hall

Representing the rejuvenation of the Lambeth area following the First World War, and forming a memorial to its local victims, this 1930s figure is mounted on the side of the Assembly Hall. He holds a flower, and a minuscule Lambeth Palace stands at his feet.

86. Albert Embankment Façade, Lambeth, (1936)

Five Relief Panels,
Two relief panels – Firemen

Sculptors: Gilbert Bayes, Stanley Nicholson Babb

The larger panels by Gilbert Bayes are on the Albert Embankment façade, over the entrance for fire engines. They depict a fire-breathing dragon; Helios and his chariot; fire-fighting mermen; and two galleons rowing in opposite directions.

The smaller panels, by Stanley Nicholson Babb, depicting firemen fighting fires, can be found on the front of the London Fire Brigade Headquarters, which had moved to its Albert Embankment location in the 1930s after outgrowing its location on Southwark Bridge Road.

87. The International Maritime Organization Headquarters, Lambeth, (2001)

International Memorial to Seafarers

Sculptor: Michael Sandle

Architects: Douglas Marriott, Worby & Robinson

From outside the International Maritime Organisation headquarters building, we see the outer surface of a ship and the crew member, somewhat out of proportion with the boat, standing on its deck. The memorial is designed to be seen from both within and without. Inside the building, viewers on the first floor look out across deck to the Thames, while from across the Thames, the sculpture is a striking focal point.

88. Former Doulton and Company Premises, 28 Black Prince Road, Lambeth, (1876)

The Doulton Artists terracotta relief

Sculptor: George Tinworth

Architect: R.Stark Wilkonson of Tarring, Son & Wilkinson

Outside the pottery company's former premises is a terracotta portrait of six Doulton artists in a workshop: Henry Doulton in the centre, Frank A. Butler, Arthur B. Barlow, Hannah Barlow, George Tinworth, the sculptor, and another worker are also featured.

89. The Jolly Gardeners Pub, 49 Black Prince Road, Lambeth, (1890)

Jolly Gardeners Relief

Sculptor: Fredrick T Callcott (attr.)

Architect: RA Lewcock

These happy chaps can be found, unsurprisingly, over the entrance to the Jolly Gardeners, a pub on Black Prince Road. The men can be seen carrying a scythe and a spade, enjoying a break in the shade of some trees.

90. East End of Westminster Bridge, next to County Hall, (1837, erected on present site 1966)

South Bank Lion

Sculptor: William Frederik Woodington

The South Bank Lion was originally commissioned by the Red Lion Brewery, along with two other lions (one of which was somehow misplaced), to stand on top of its buildings; the base of this lion states simply 'BREWERY'. The lion was removed from the site following the closure of the brewery, for restoration and cleaning. It was during this process that a small door was found in the lion's back, which was found to contain a bottle, which contained two pieces of paper. One was an advert for the Coade stone; on the other was a handwritten note from the sculptor: 'Mr. Woodington, sculptor, May 24, 1837, Princess Victoria's birthday.'

91. 111a Lambeth Road, (1880-poss.)

Relief panel of figure holding a bell

Sculptor: unknown

Architect: Stanley C McMurdie

This building used to be The Bell pub; the rather unusual figure on the outside appears to be an unusually muscular child ringing an oversized bell.

92. Former London County Hall, Westminster Bridge Road, (1915-1921)

Figures representing Benevolence and Humanity

Sculptor: Ernest Cole

Architect: Ralph Knott

These two male figures, representing Benevolence and Humanity, sit back-to-back and each holds a globe; similar figures are placed around the building. The works were not met with great critical acclaim, and were deemed out of context on such a building.

93. Main Entrance of Waterloo Railway Station, York Road, (1922)

War Memorial Arch

Designer: JR.Scott

Architects: JW Jacomb-Hood, AW Szlumper

At the entrance to Waterloo Station is the War Memorial Arch, commemorating the staff who died during World War I. To either side of the arch are scenes from 1914 and 1918; the former portraying War, a bare breasted woman wielding a knife and flaming torch and towering over her victims, and the latter displaying Peace, holding a statue of Victory atop a globe.

94. Wareham House, Fentiman Road (South Western-Corner), (1951/2)

Relief of Boys Playing Football

Sculptor: Peter Peri

These scenes were designed to lighten the dreary post-war housing estates nearby: the architect Peter Peri crafted a scene made out of light coloured concretes showing seven boys playing football on one wall, and children playing with their mother on another.

95. Vauxhall Bridge, (1904-07)

Figures of Science, Fine Arts, Local Government and Education/Ceramics, Engineering, Architecture and Agriculture

Sculptors: Alfred Drury and Frederick William Pomeroy

Architects: Sir Alexander Binnie, Sir Maurice Fitzmaurice and WE Riley

These allegorical figures are situated on the sides of Vauxhall Bridge, and gaze up and down the Thames. Dogged by criticism and controversy, the figures were finally in place on the Bridge just over ten years after the initial design consultations began, to be met with the problem that, from the banks of the river, the figures were near imperceptible. One has to question the wisdom of having a figure of Agriculture that shows a remarkable resemblance to the Grim Reaper on the side of a bridge that people have to cross.

**96. St Dunstan's College,
Stanstead Road, Catford, (1888)**

*Tympanum Reliefs: St Dunstan with Masons
and St Dunstan with Metalworkers*

Sculptor: Herbert Ellis

Architect: EN Clifton

These scenes, above the ground floor
windows of St Dunstan's College, depict
St Dunstan watching craftsmen at work.
Holding paper and crosier in one, he
watches as a man chisel decorations on to
a column while another lowers a block of
stone onto a table; in the other, he addresses
two metalworkers in their workshop.

**97. Deptford Town Hall,
New Cross Road, (1905)**

Tympanum Relief: Naval Battle

Sculptors: Thomas and Edward Nicholls

Architect: Lanchester, Stewart & Rickards

Above the front of the former Deptford
Town Hall is a representation of a naval
battle, with choppy seas and ragged sails.
The building has a number of nautical
decorations, representative of the importance
of the local Royal Naval Dockyards.

**98. Outside Woodfield House,
Dacres Road, Lewisham, (1854)**

Sculpture of Pacific

Sculptor: Raffaelle Monti

Unconcerned by his lost nose, toes and the
graffiti with which he is adorned, Pacific
is happily reclining against a whale. While
he may seem somewhat out of place in
Lewisham, Pacific was one of six such
pieces personifying seas and rivers, three of
which are now lost.

**99. Tower House, High Street,
Lewisham, (1933)**

Modes of Transport Reliefs in Terracotta

Architect: Samuel William Ackroyd

These are found running in a chain around
the top story of the one-time RACS
building, and also at the end of the second
floor. They depict toy-like trains, lorries
and boats.

**100. Bromleigh House,
St Saviour's Estate, Abbey Street,
Bermondsey, (1959)**

*Memorial drinking fountain
to Violet Alice Tritton*

Sculptors: Students of the Sculpture
Department, Camberwell School of
Arts and Crafts

Violet Alice Tritton worked for Time
and Talents Association, a charity that
helped those living in poor conditions in
Bermondsey and Rotherhithe. After her
death the local council agreed to install a
water fountain in her memory.

**101. Gateway of former Alaska Factory
building, Bermondsey, (c 1869)**

Seal Relief

Above the gateway to the Alaska Factory
(Martin's Fur Merchants) is a seal climbing
over rocks up the beach. Unsurprisingly, the
seal was the emblem of the company; the
factory has since become residential housing.

**102. Shipwright's Arms,
88 Tooley Street, Bermondsey, (1884)**

Ship's figure-head pub sign

Architect: George Treacher

Above the entrance to the Shipwright's
Arms pub, this sculpture appears to be
holding up the corner of the building,
despite her questionable attire. Painted in
bright colours – green dress, golden hair,
nipple and toenails in matching red –
she looks down upon those who enter
the building.

103. London Leather Hide and Wool Exchange (former), Weston Street, Bermondsey, (c.1878)

Sculpted roundels

Sculptor: Unknown (possibly Charles Henry Mabey Snr)

Architect: George Elkington & Sons

These roundels display different stages in the leather-making process: three scenes depict men sorting the new hides; shaving them; and putting them into a tanning pit. Further around the building are roundels representing the tanned hides hanging in a room and the finished hides being inspected. This was a crucial trade for the region, which became a particular focal point for the leather trade in the eighteenth and nineteenth centuries.

104. London South Bank University Day Nursery, 12 Borough Road, Southwark, (1897-8)

Truth holding the mirror up to Nature

Architects: CJ Phipps and Arthur Blomfield Jackson

Sculptor: E Caldwell Spruce

This building was originally a library, which explains the image of Truth, holding an oil lamp, instructing those around her. The space it occupies, on the west side of the building, was originally intended to house a memorial to Queen Victoria (who was, however, at this time very much alive). In another relief, St George slays the dragon.

105. Central Buildings, 24 Southwark Street, (1866-8)

Pediment sculpture and keystone heads

Architect: RH Moore

This was once the Hop and Malt Exchange. Above the front stands, slightly strangely, an eagle, which is watching miniscule men below it at various stages of the hop-brewing process. One keystone contains the carved head of a mysterious man with luxurious facial hair. Some have speculated that it depicts the architect, but it remains unknown.

106. 17 Camberwell Green, (c.1899)

Architectural sculpture

Over the doorway to the building lie a man and a woman, presenting the word 'SURGERY' to the world (this, however, originally read 'BANK'). The building used to be the National Westminster Bank, but is now a doctor's surgery. A three-headed cherub figure lurks below, gazing down at the year of the feature's installation: 1899.

107. Battersea Arts Centre, Lavender Hill, (1892-3)

Pediments of The Arts, the Borough, Literature/Work, the Borough, Progress

Sculptors: Paul Raphael Montford with Horace Mountford

Architect: Edward William Mountford

These sculpture pediments are located on the outside of the former Battersea Town Hall. The Borough is, perhaps worryingly, represented as a child, sitting between two advisory figures: the Arts and Literature, and Work and Progress. The figures can be seen to represent what should be the concerns of local government.

108. Wandsworth Town Hall and Municipal Offices, (1936)

Six Relief panels

Sculptors: David Evans (Wandsworth Panel); John Linehan (all other panels)

Architect: Edward A Hunt

These panels, located on Wandsworth High Street depict local scenes in Wandsworth, Streatham, Clapham, Putney and Balham and Tooting. A lengthy inscription describes the historical events depicted. Each panel depicts an event which is connected to the founding of each borough.

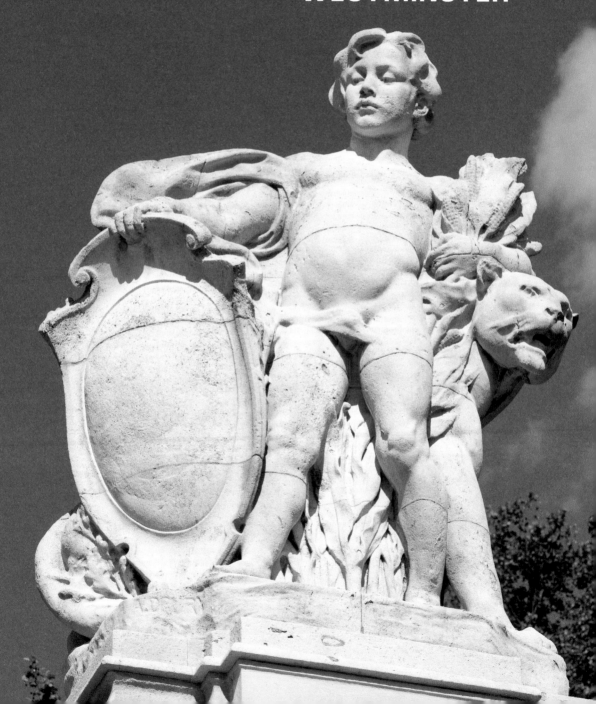

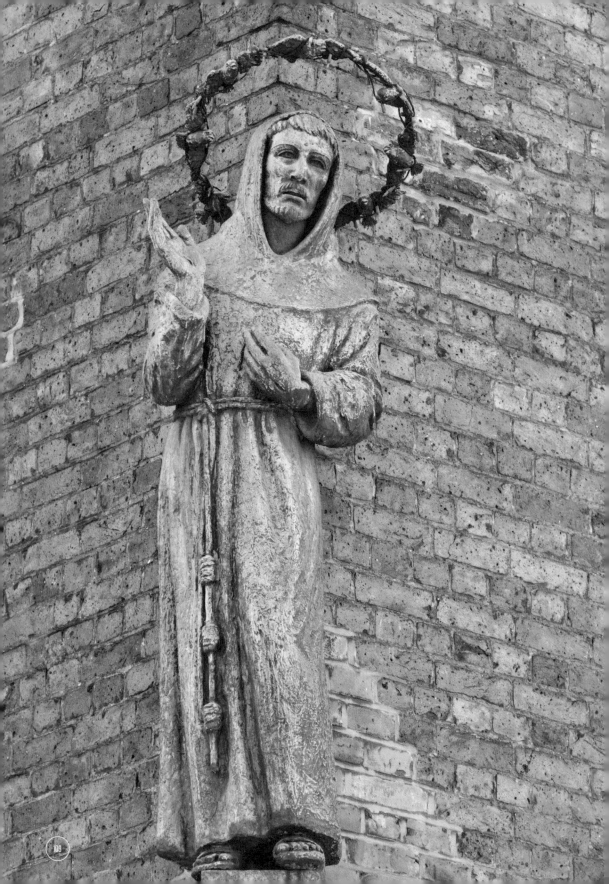

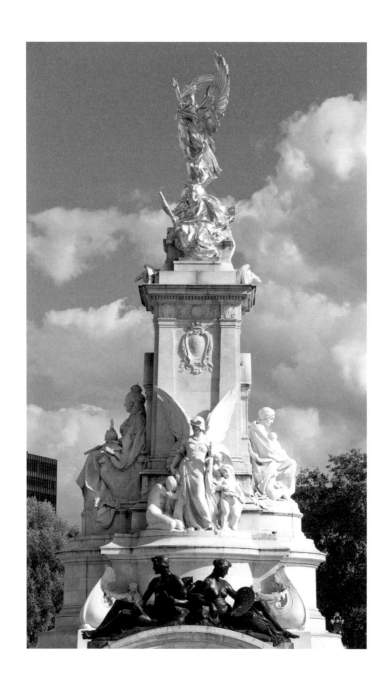

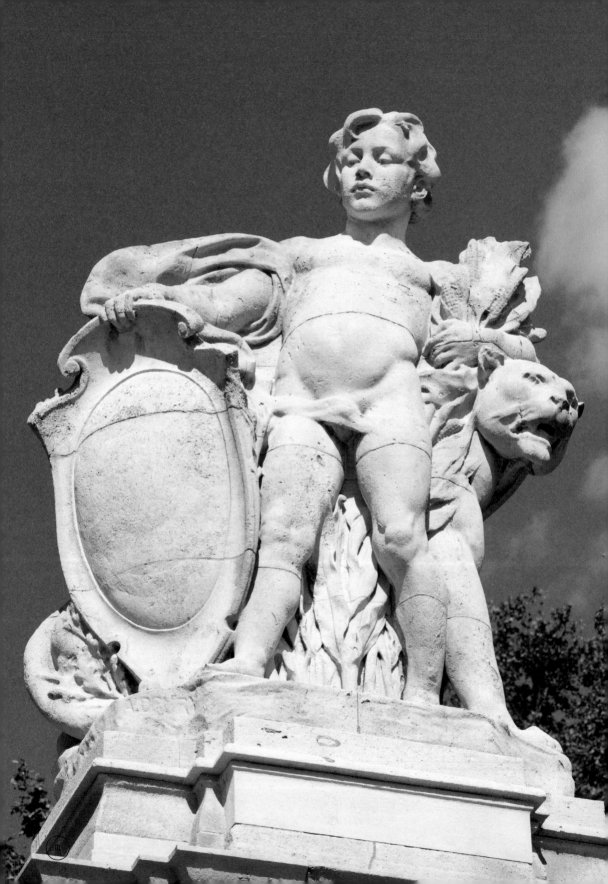

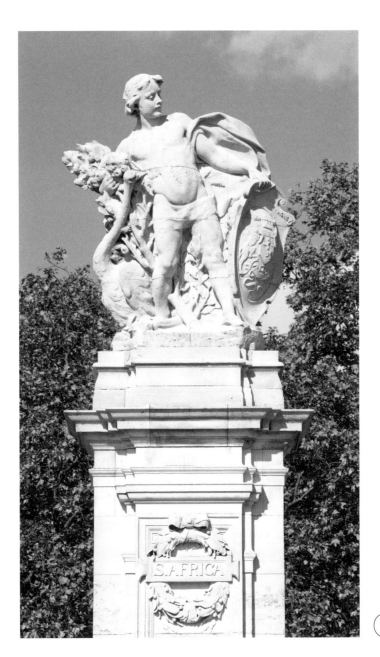

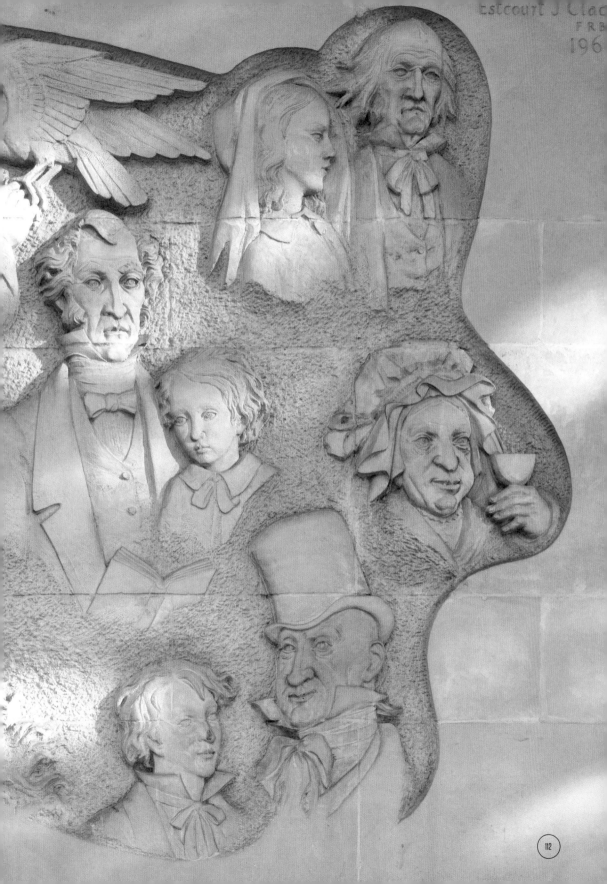

Estcourt J Clac
FRB
196

112

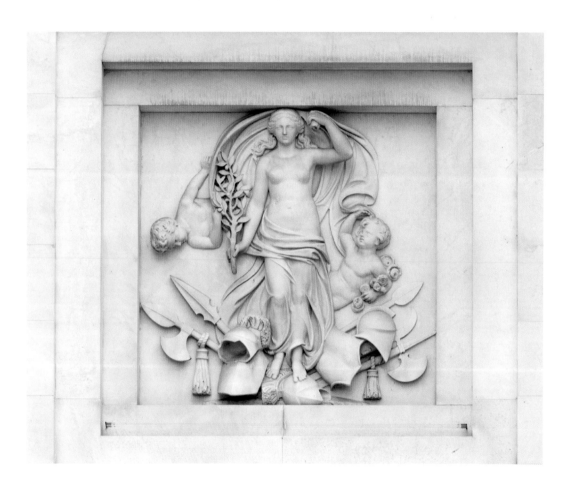

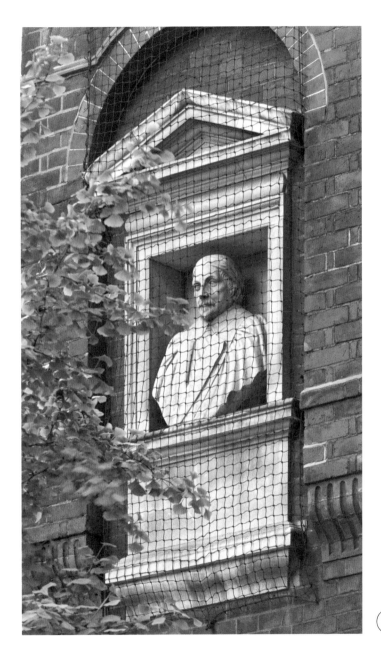

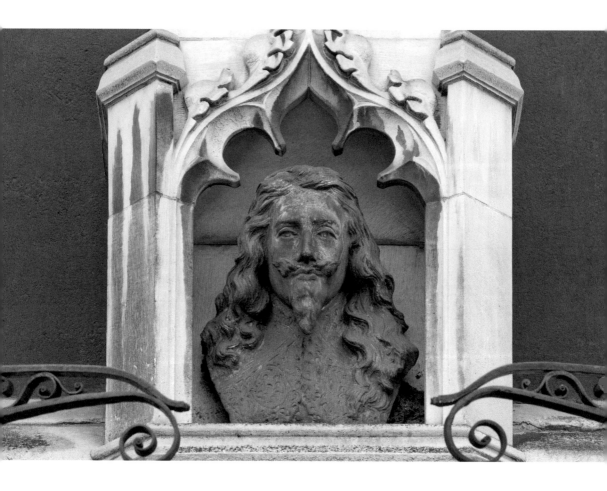

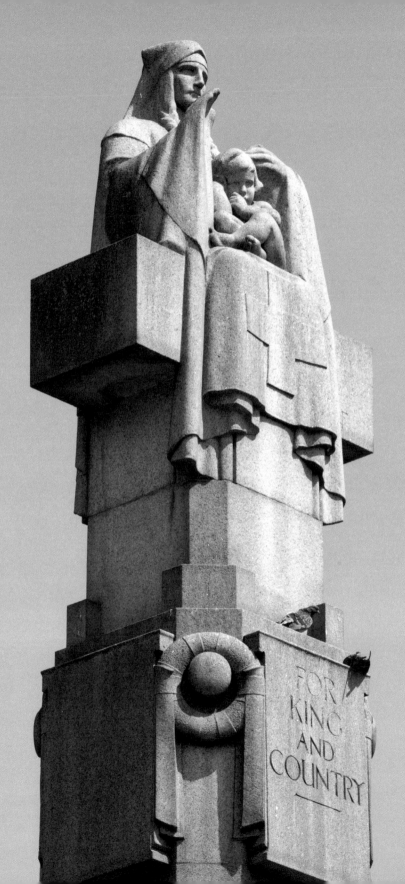

FOR
KING
AND
COUNTRY

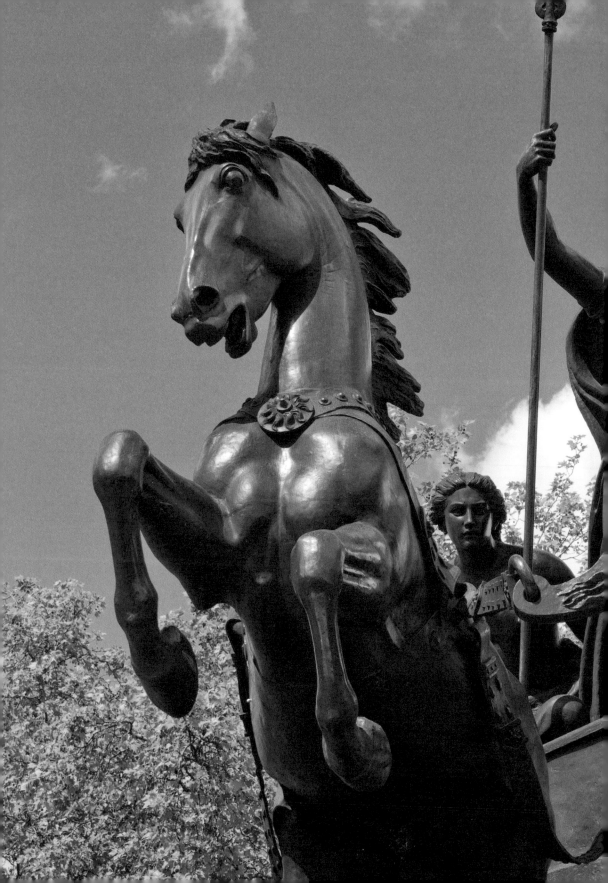

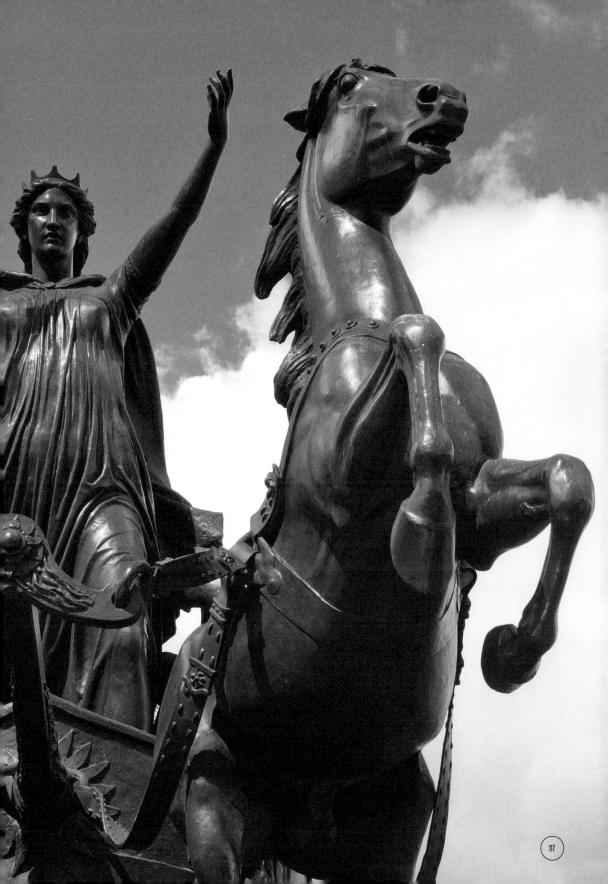

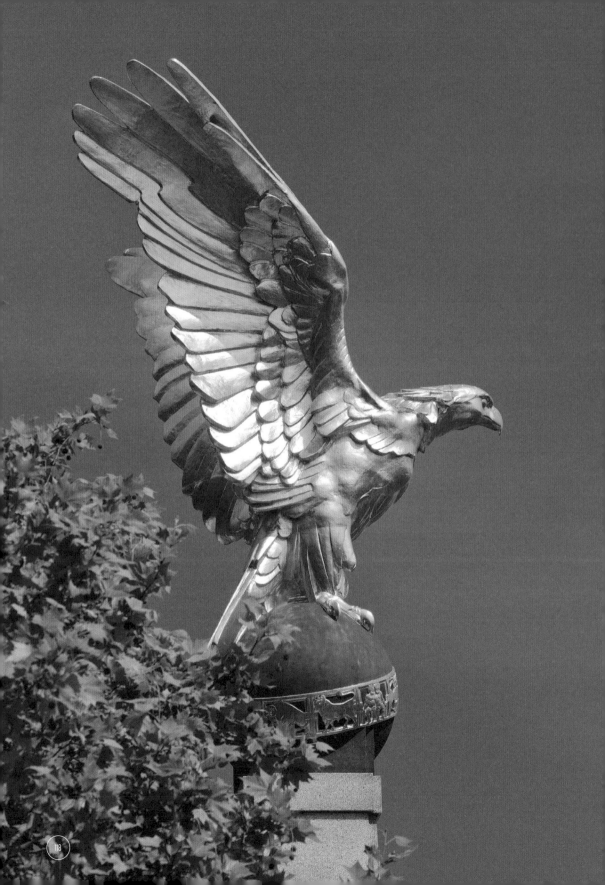

REFERENCE

109. The Friary,
47 Francis Street, (1961)
Statue of St Francis

Sculptor: Arthur Fleischmann

St Francis stands high up, on the corner
of the building, which was originally built
as an orphanage in the mid-nineteenth
century. Here, he wears the traditional habit
and has a halo of birds flying around his
head. The sculptor claimed that if St Francis
were in London today, he would preach a
special sermon to the city's sparrows.

110. The Mall, West End in front
of Buckingham Palace, (1911)
Queen Victoria Memorial

Sculptor: Sir Thomas Brock

The Queen Victoria Memorial stands right
in front of Buckingham Palace. Victoria
can be seen seated, facing towards the
Mall; on the opposite side is the statue
of Motherhood. Justice and Truth take
the places between. At the very top is the
gilded figure of Winged Victory, who is
standing on a globe.

111. The Mall, (1905-08)
Statues representing South Africa
and West Africa

Sculptor: Alfred Drury

At the end of the Mall stand South Africa
and West Africa, represented by European
boys surrounded by exotic animals. South
Africa contains depictions of an ostrich
and a monkey, West Africa by the rather
more dangerous lioness and eagle.

112. Ferguson House,
junction of Marylebone Road and
Marylebone High Street, (1960)
Charles Dickens Panel

Sculptor: Estcourt J Clack

In this panel we see Dickens' profile,
surrounded by the products of his
imagination: characters from his books. The
figures are all taken from works produced
by Dickens while living at 1 Devonshire
Terrace, and form a response to (successful)
plans in the 1950s to demolish this
important site.

113. Marble Arch, Oxford Street
Panels depicting Peace with trophies of War;
Valour and Virtue

Sculptor: Sir Richard Westmacott

Architect: John Nash

These panels can be found on Marble Arch,
which was designed to function as both an
elaborate entrance to Buckingham Palace
and as a memorial for the Napoleonic
Wars. The Arch was chequered by calls
for its removal throughout the nineteenth
century, when gardens were deemed a more
appropriate replacement.

114. United Westminster Almshouses
(front), Rochester Row
Busts of Rev James Palmer (south gable)
and Emery Hill (north gable)

Sculptor: Anonymous

(1882-Palmer) (c1675-Hill)

The bust of Emery Hill is considerably
older than that of James Palmer, dating to
the seventeenth century; Palmer was added
in the Victorian period to complement
the installation. Both figures founded
almshouses: the United Westminster
Almshouses, funded by Palmer, were
built on the site of those founded by Hill.
Palmer was a vicar known for his frugal
lifestyle, while Palmer was a wealthy
property speculator.

115. St Margaret Westminster,
St Margaret Place, (Erected 1954)
Bust of Charles I

Sculptor: Unknown

Charles I's head, rather fittingly for the
victim of regicide, stares across to the
statue of Cromwell outside the House
of Commons. A second bust was also
created, and sits in the Banqueting Hall
at Whitehall, which was the site of the
King's execution.

116. St Martin's Place (on island in road between National Portrait Gallery and St. Martin in the Fields, (1920)

Memorial to Edith Cavell

Sculptor: Sir George Frampton

Edith Cavell trained as a nurse and, during World War I, assisted soldiers trapped in Belgium following the German invasion in 1914. Her activities, however, were discovered by the Germans, and she was executed by firing squad in 1915. This memorial, which presents the figure of Cavell overlooked by Humanity dressed in a nurse's robes, was one of many for the nurse: the execution was met by widespread disgust, and Cavell's body was returned to her Norfolk home following a ceremony at Westminster Abbey; the Belgian hospital in which she served was renamed as the École Edith Cavell.

117. Westminster Bridge (facing the Palace of Westminster), (1902)

Sculpture of Boadicea and her two daughters

Sculptor: Thomas Thornycroft (with assistance from Hamo Thornycroft)

This pedestal sculpture serves two purposes: as a bronze statue of Boadicea, standing on a chariot drawn by two horses, and a tool store, which can be accessed through a door at the back of the pedestal.

118. Whitehall Steps, opposite the Ministry of Defence, (1923)

Royal Air Force Memorial

Sculptor: William Reid Dick

The bronze, gilded eagle at the top of this RAF memorial is nearly 4 metres tall. It stands atop a globe; the inscription below is from Exodus: 'I bare you on eagles' wings and brought you unto myself.'

119. Victoria Tower Gardens (Southern End near Lambeth Bridge), (1923)

Drinking Fountain with Animal Groups

Sculptor: Miss Harris (assisted by Charles Sargeant Jagger)

This drinking fountain was added as part of a playground for poor children from the area. It went through multiple design possibilities and budget increases before a Miss Harris sculpted the animal groups pictured.

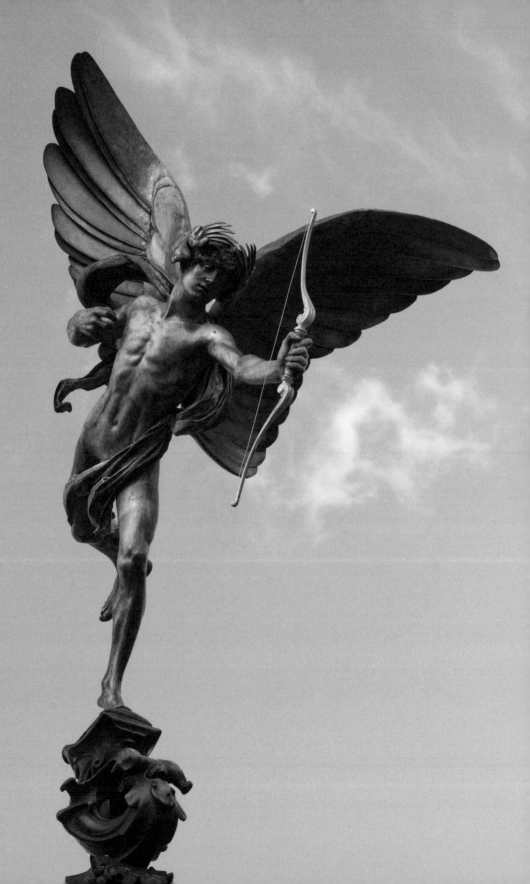

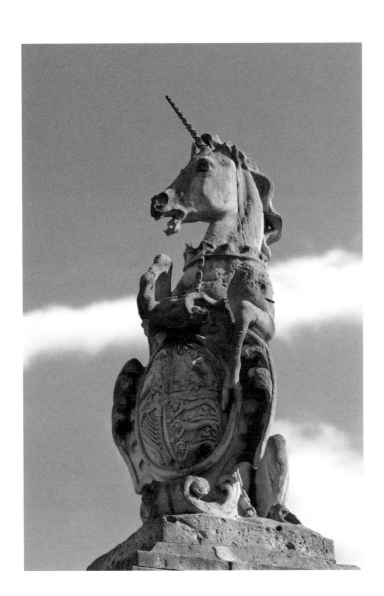

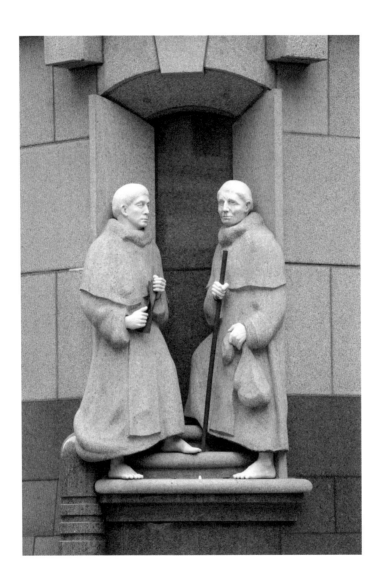

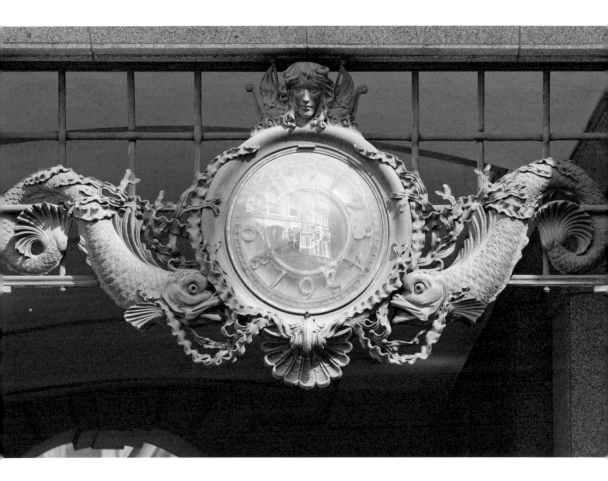